IMAGES OF AMERICA

BEACON HILL

CYNTHIA CHALMERS BARTLETT

ARCADIA

First published 1996
Reissued 2004

Published by Arcadia Publishing,
an imprint of the Tempus Publishing, Inc.
Charleston SC, Chicago, Portsmouth NH, San Francisco

Printed in Great Britain

Library of Congress Card Catalog Number: 2003110944

For all general information contact Arcadia Publishing at:
Telephone 843-853-2070
Fax 843-853-0044
E-mail sales@arcadiapublishing.com
For cusomer service and orders:
Toll-Free 1-888-313-2665
Visit us on the internet at http://www.arcadiapublishing.com

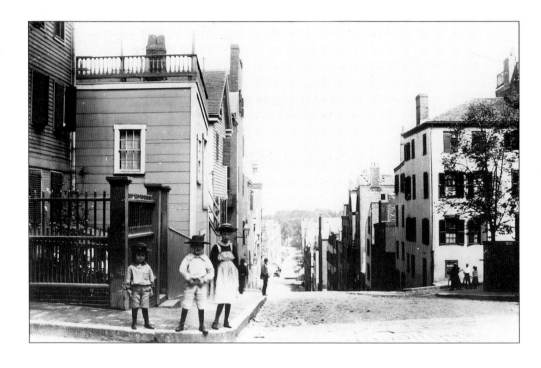

IMAGES OF AMERICA

BEACON HILL

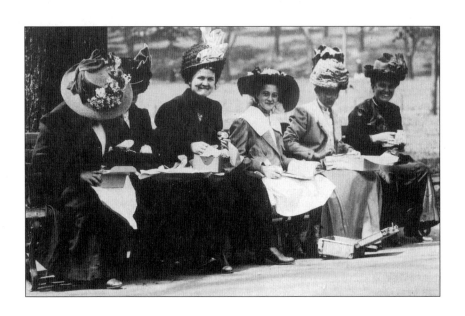

Contents

From Rural Pasture Land to Prime Real Estate

Build thee more stately mansions,
O my soul, As the swift seasons roll!
Leave thy low-vaulted past . . .

—Oliver Wendell Holmes

Boston's building fury of the nineteenth century, so poetically expressed by Oliver Wendell Holmes, took hold first on the summit of Beacon Hill. A few years after the American Revolution, Boston's economy flourished and a new wealthy class emerged seeking not only power but also land on which to build homes for their growing families. Simultaneously, Bostonians yearned for a new state capitol building to replace the Old State House, which stood as a reminder of the days under English rule. The proposed site for the capitol was atop a high hill in an area of pasture lands and steep mountainous slopes, today's Beacon Hill. The residential future of the hill would be developed within only a few years after the completion of Bulfinch's State House in 1798. Beacon Hill would soon offer some of the finest urban living in the world. However, it is important to bear in mind that although this elegant neighborhood has not changed much from the early days of the nineteenth century, the earliest residents would never have recognized the area as we know it today.

When the first settler of Boston, an eccentric Anglican clergyman named William Blackstone (or Blaxton), established his residence on the slope of what is now Beacon Hill in the 1620s, the area was so rural that Blackstone was able to indulge himself in a hermit's life. The area was comprised of three spurs: Cotton Hill on the east, Sentry Hill in the center, and West Hill, or Mount Vernon, on the west. Collectively, the region was called "Trimountain." In order to keep a lookout for encroaching enemies, the general court ordered a beacon erected on Sentry Hill in 1634–35, hence the name Beacon Hill came into existence. By 1645, most of the surrounding area had been divided into hilly, rural pasture lots, and in 1722 there were approximately sixty houses in the area. Before 1800, Myrtle Street was the site of a ropewalk where a long wooden shed-like structure housed the production of rope. The ropewalk building extended approximately 1,000 feet to accommodate the odoriferous business of entwining hemp. Aside from the ropewalk and the numerous wooden dwellings on the North Slope, Beacon Hill remained a hilly pasture land until the early nineteenth century. However, Boston's post-Revolution years awoke a feverish ambition in local developers and Beacon Hill would soon be changed forever.

Precipitating the hill's metamorphosis, visionaries saw the State House commanding a

powerful presence by looming over their city perched high upon a hill. The proposed site of Sentry Hill's summit generated land speculation in the surrounding areas and resulted in the land removal that would flatten out all three peaks and fill in marshlands, expanding the area for even more real estate development. Gravel was first carted away from Sentry Hill in horse-drawn loads, filling in 50 acres beyond today's Causeway Street until the hill's height was reduced roughly 60 feet. This process completed enabled the construction of the city's capitol, designed by the young Charles Bulfinch. The new subtle and elegant American Federal style introduced in this edifice would significantly influence Beacon Hill's architectural development.

Meanwhile on Mount Vernon, residents and developers began leveling Beacon Hill's South Slope in 1799, marking the first step in the creation of the most fashionable residential district in early-nineteenth-century Boston. This area's development was initiated by an enterprising group called the Mount Vernon Proprietors (Jonathan Mason, Harrison Gray Otis, William Scollay, and Charles Bulfinch), who purchased 18 acres of the most attractive land in the Trimountain vicinity owned by John Singleton Copley. This area was roughly between Beacon Street and the Myrtle Street ropewalk, and from Joy Street to Cambridge Bay. The landfill was used mostly to create Charles Street and the flat of Beacon Hill.

In a brief period of time, Beacon Hill's not-so-attractive rural and hilly land was transformed into highly desirable real estate. Streets were then cut through and named after natives like Pinckney, Joy, and Revere. In 1814 about 40 percent of the land contained a mix of brick row and mansion houses. By 1840 virtually all available lots were filled, including Louisburg Square, laid out in 1826.

The proprietors' original concept for the South Slope varied greatly from the end result. Their plan for the land south of Pinckney Street called for large free-standing mansions surrounded by gardens and carriage houses, setting a standard for domestic architecture in the new neighborhood. Later plans show a version of the original proposal more in line with the present plan of Beacon Hill. Only a handful of these showpiece mansions were eventually built and only a couple still remain. Charles Bulfinch, one of the proprietors and the major architect of this period, was able to indelibly impress upon the local scene a uniformity in style that would shape the character of the hill. In 1802, Otis and Mason commissioned Bulfinch to build the first two mansions on Mount Vernon Street, opposite Walnut Street. These were designed in the new American Federal style; predominant features included arched entrances, flat facades, and brick masonry, which replaced wooden construction in the prevalent frame house.

Although the concept of free-standing mansions dominating the local scene did not prevail, the new architectural principles did. New expressions emerged as variations on this original theme. For example, from the Federal style, the row house naturally evolved; in this structure flat facade houses were simply built side by side. Subsequently, in 1807, the houses at 54 and 55 Beacon Street showed that the row houses could break out of the flat mass of stone with the bow front design and bay windows, thereby catching the warmth and brightness of the sun. The bow front became a signature of Beacon Hill.

In 1819, architect Alexander Parris introduced the Greek Revival principles of post-lintel doorways and columns topped with classically designed capitals in his commission at 42 Beacon Street, the present-day Somerset Club. Subsequently, the Greek Revival style became contagiously popular on the hill. However, by 1840 the area's building boom came to an end, most of the land having been developed. During the remaining years of the nineteenth century, many buildings were altered with architectural details fashionable at the time, such as Victorian-inspired ornate doorways, mansard roofs, and bay windows. This explains why many of Beacon Hill's houses display eclectic architectural styles today.

The North Slope, an area bounded today by Pinckney, Cambridge, Joy, and Charles Streets, developed almost entirely independently from the South Slope and was more or less an extension of the West End. In the eighteenth century, a few scattered frame houses lined the hilly streets, but by the mid-nineteenth century the popular row houses became a standard type

of dwelling on the North Slope. Black families had inhabited the West End since the 1760s and after the 1820s many more had settled along the North Slope. There, the nation's first black church, called the African Meeting House, served as a gathering place for the community's religious, social, and educational functions, and attracted many African-Americans to the area.

Between 1865 and 1900, Boston's African-American population increased fivefold because of the city's appeal to the first generation of ex-slaves migrating north after the Civil War. The African Meeting House could no longer accommodate the church's membership. By the middle of the century, the African-American community had begun to relocate to other areas of the city, and new immigrants came to settle in the area from Europe, including a large number of Jews.

By 1904 the African Meeting House was converted to a Jewish synagogue and a few years later on Phillips Street the Vilna Shul, an orthodox congregation, was built for the sizable Jewish population now gathered on the North Slope and the West End. Beginning in the 1890s, tenements replaced many of the row houses on the North Slope and the West End in order to accommodate the many waves of European immigrants in the late nineteenth century. All of Boston experienced an inundation of immigrants at this time, giving a strong character to the city and resulting in great diversity. Beacon Hill was no exception.

In the late 1950s, the Boston Redevelopment Authority (BRA) ruthlessly carried out a plan to demolish the tenement district of the West End in order to make room for luxury condominiums in high-rise buildings. Although the North Slope escaped this fury of destruction, the social makeup of the community—which had cultural and social ties to the West End—changed significantly within a few years. For example, Jews who had settled on the North Slope began relocating to other areas in Boston, leaving the Vilna Shul and the synagogue without a congregation.

The thoughtless demolition of the West End galvanized local support for historic preservation. In 1955 Beacon Hill's South Slope became a historic district, and the North Slope followed in 1963. In the 1960s, the Black Heritage Trail was established to explore the history of nineteenth-century African-Americans in the city; all fourteen sites on the trail are located in Beacon Hill. Fortunately, these efforts have protected the external appearances of the neighborhood's buildings and monuments from inappropriate alteration, and the rich history of Beacon Hill remains evident.

Aesthetically, the attraction of Beacon Hill lies in the unity of its architecture. However, upon closer inspection, the diversity of form in doorways, windows, and ironwork becomes apparent. These little surprises and details in this elegantly textured neighborhood make a walk through Beacon Hill feel more like a voyage of discovery. The hill's infinite riches, such as its antique purple windows, quiet cul-de-sacs, and converted horse stables steer the imagination into a nineteenth-century world of grandeur. Beacon Hill is truly a special place, so abundant in charm and history that it holds out the promise of more to discover the next time the hill's cobbled streets beckon one's return.

Note: Throughout the book, photographs borrowed from the Boston Public Library, Print Department appear with the credit BPL; images borrowed from the Society for the Preservation of New England Antiquities appear with the credit SPNEA.

One

Vistas and Street Views

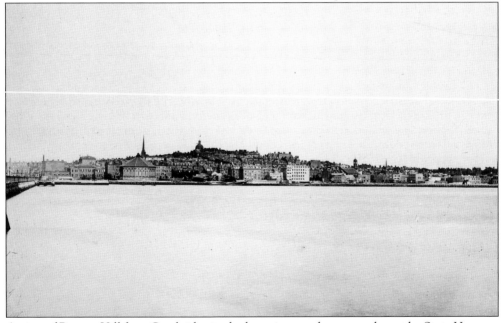

A view of Beacon Hill from Cambridge in the late nineteenth century shows the State House as it was intended to be seen, taller than any other structure in the area. Today the gold-domed State House, perched at the crest of Beacon Hill's dense neighborhood, is dwarfed by the high-rise buildings of downtown Boston. Nevertheless, the glistening gold from the dome still dominates Boston's landscape. (Courtesy BPL.)

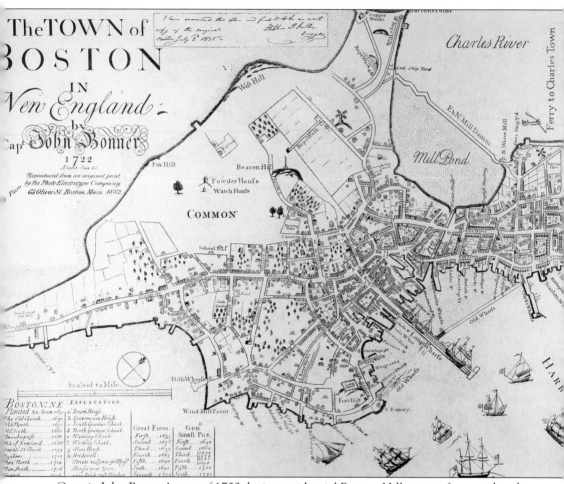

Captain John Bonner's map of 1722 depicts residential Beacon Hill in its infancy with only one house on the South Slope, originally belonging to Boston's first settler, William Blackstone (or Blaxton). His house was located down the steep hill from the beacon. In the Colonial era, Boston was a tiny peninsula with very little land. The hills had to be leveled to generate landfill and to provide flatter areas on which to build. This map of Boston is the oldest one in existence. It shows streets as well as landmarks and illustrates that the earliest growth of Boston was in the North End and downtown. Beacon Hill's development took place mostly in the early 1800s after the construction of the State House. The area became a fairly dense residential community by the mid-nineteenth century. (Courtesy BPL.)

Beacon Hill, shown here c. 1811 from Derne Street, was named after a beacon that was erected about 1634–35 on the summit where the State House now stands. From a tall mast an iron crane was suspended to receive combustible material. When the material was ignited, smoke and sparks could be seen a great distance inland, giving the city warning in the event of an invasion. (Reproduction from a watercolor by J.R. Smith, courtesy BPL.)

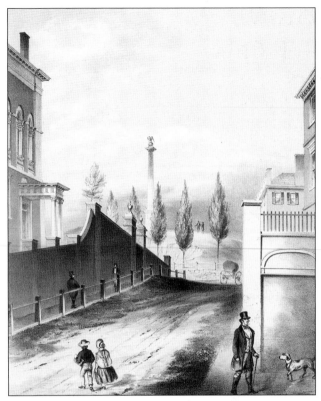

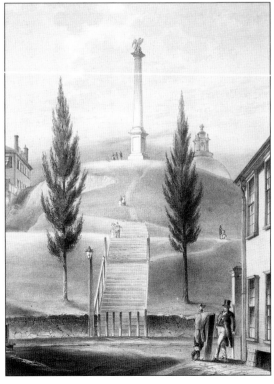

The beacon was blown down in 1789 and replaced by a brick monument. A 60-foot Doric shaft topped with a gilded wooden eagle supporting the American arms commemorated those who fell at Bunker Hill. It is viewed here from the corner of Temple and Derne Streets c. 1811, but the monument would soon be taken down in order to level the hill. A reproduction granite monument was erected in 1898 on the east side of the State House's new addition. (Reproduction from a watercolor by J.R. Smith, courtesy BPL.)

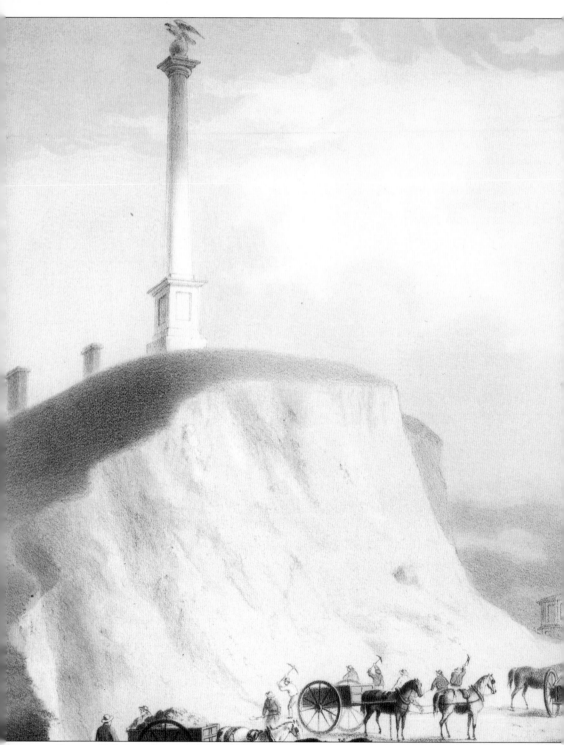

Beacon Hill from the site of the old reservoir, between Hancock and Temple Streets, shows the removal of land *c.* 1811. The laying of the cornerstone of the new State House in 1795 caused rapid changes to take place on the summit and South Slope of Beacon Hill. In the same year,

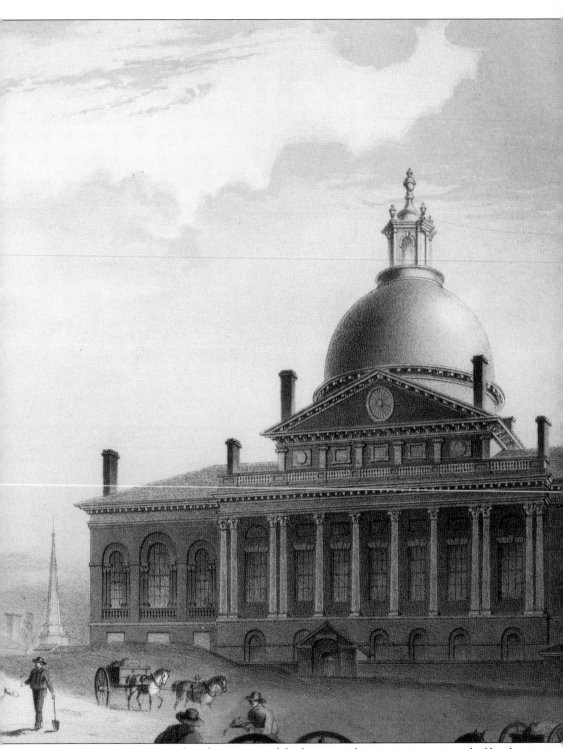

the Mount Vernon Proprietors bought 18 acres of the largest and most attractive parcel of land belonging to John Singleton Copley and began the development of today's Chestnut and Mount Vernon Streets. (Reproduction from a watercolor by J.R. Smith, courtesy BPL.)

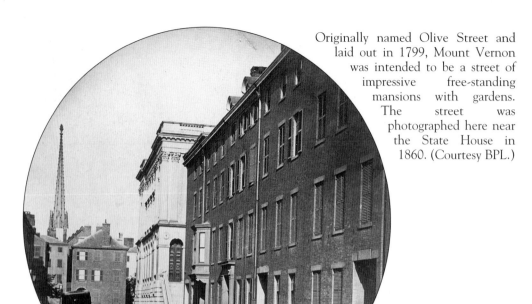

Originally named Olive Street and laid out in 1799, Mount Vernon was intended to be a street of impressive free-standing mansions with gardens. The street was photographed here near the State House in 1860. (Courtesy BPL.)

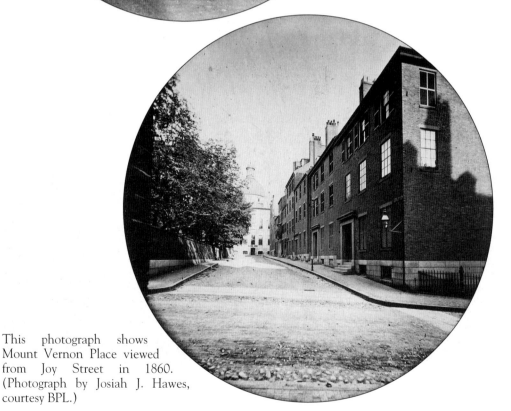

This photograph shows Mount Vernon Place viewed from Joy Street in 1860. (Photograph by Josiah J. Hawes, courtesy BPL.)

14

Henry James, well-known writer of the late nineteenth century, once declared that Mount Vernon was "the only respectable street in America." (Photograph by Leslie Jones, courtesy BPL.)

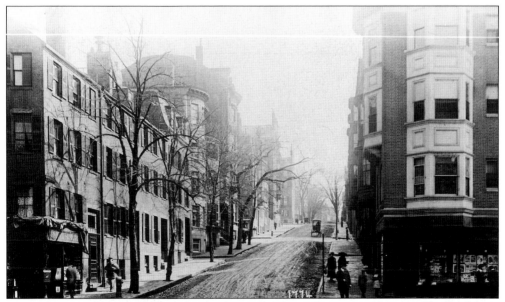

Mount Vernon, Beacon Hill's widest and greenest street, begins its ascent at Charles Street. The street was photographed here with small businesses on the corner c. 1905. (Courtesy BPL.)

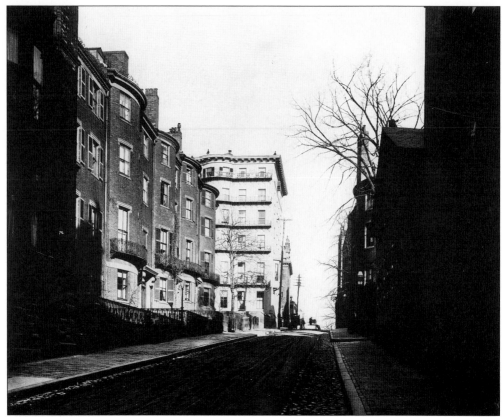

Joy Street was named after Dr. John Joy, an apothecary and one of the hill's earliest residents. A group of converted communal stables are shown on the right. (Courtesy Library of Congress.)

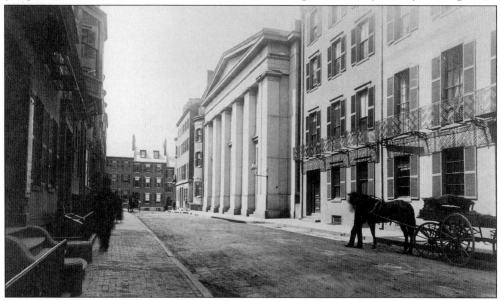

This photograph, taken *c.* 1870s, shows old Ashburton Place with the Mount Vernon Church, which has since been lost to the State House's expansion. (Courtesy BPL.)

16

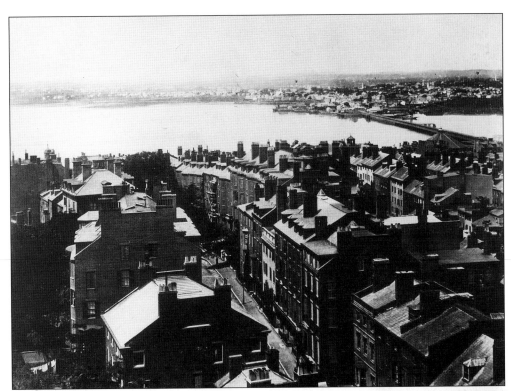

This spectacular view looking northwest reveals early Beacon Hill from the State House in 1857. Bulfinch's State House caused the almost immediate transformation of the hill's southwest slope from pasture land to prime real estate. (Courtesy BPL.)

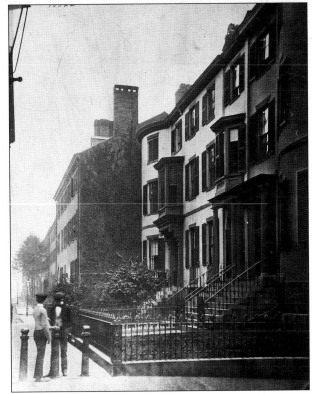

Beacon Hill Place used to lie off Bowdoin Street in 1855, but the area was razed in 1895. (Courtesy BPL.)

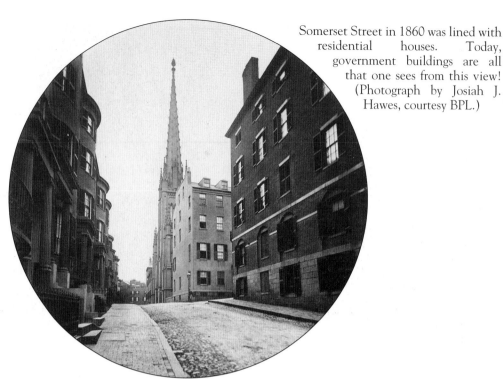

Somerset Street in 1860 was lined with residential houses. Today, government buildings are all that one sees from this view! (Photograph by Josiah J. Hawes, courtesy BPL.)

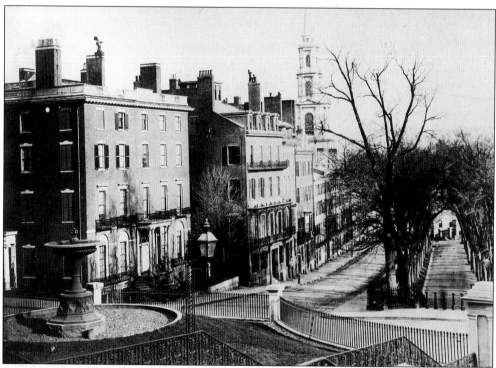

A view of Park Street from the State House in 1857 shows Bulfinch's Amory-Ticknor House in the foreground adjacent a row of four uniform townhouses with long wrought-iron balconies under the windows. (Courtesy BPL.)

18

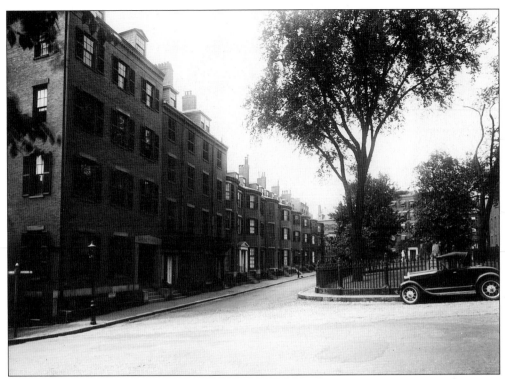

Memories of Beacon Hill's grand old past still cling to Louisburg Square, laid out in 1826. This photograph, taken over one hundred years ago, shows how little Louisburg Square has changed over the years. This is due largely to a fiercely protective group of residents, the Beacon Hill Architectural Committee, and the Louisburg Square Proprietors Association, America's first homeowners' association, established in 1834. (Courtesy BPL.)

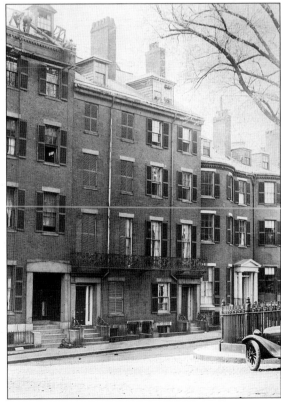

One of Boston's finest neighborhoods, Louisburg Square is comprised of a private oval park surrounded by a cobblestone roadway and attractive Greek Revival houses. Since 1844, it has remained a privately owned property, even issuing its own parking tickets. For generations, residents have maintained their own holiday traditions such as strolling carolers, hand-bell ringers, and candle-lit windows. (Courtesy BPL.)

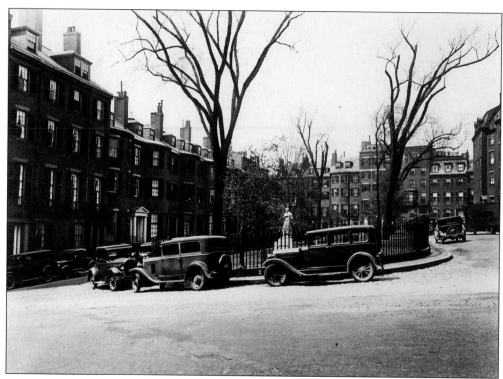

The statues of Aristide the Just and Columbus in the square were erected in 1850 and are shown here in 1915. They were donated by Joseph Iasigi, a Mediterranean merchant and ship owner who resided at 3 Louisburg Square. (Courtesy BPL.)

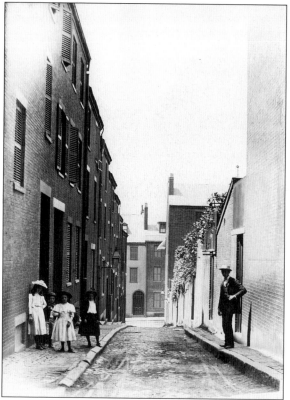

By the 1830s, Acorn Street, pictured here in 1890, was given over to stables for the horses of wealthy residents on the hill. A slim cobbled street, it was later called Kitchen Street because the small houses were lived in by servants. (Photograph by John W. Robbins, courtesy SPNEA.)

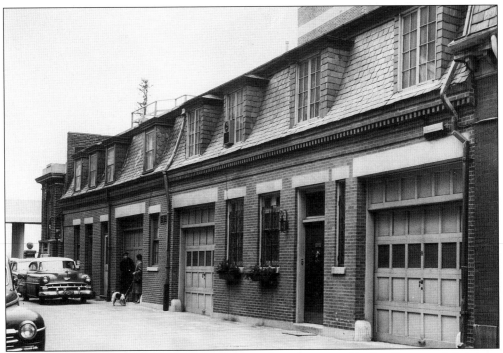

On the so called "flat" of the hill, the area stretching between Charles Street and the river, many stables were kept for the proprietors living on the South Slope. A number of those structures, such as those shown here in Beaver Place in 1956, have been converted to homes since the passing of the horse-and-buggy era. (Courtesy *Boston Herald*.)

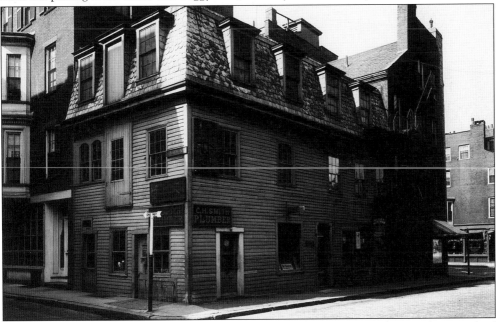

The hill's "flat" neighborhood developed mostly after the 1850s. This July 1930 photograph of 31 River Street, between 63 1/2 to 65 Chestnut Street, shows a plumbing business, a French shoemaker, and an antique shop. (Photograph by Leon Abdalian, courtesy BPL.)

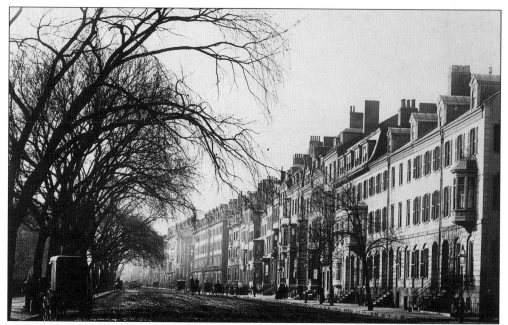

The buildings on this flat area of Beacon Street opposite the Public Garden, shown here in 1887, were built on landfill in the early 1800s. (Courtesy BPL.)

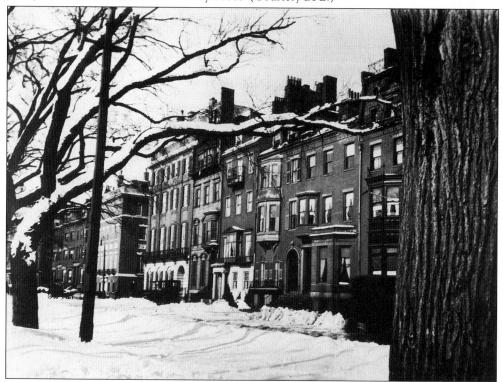

This 1925 photograph of Beacon Street opposite the Public Garden includes the future site of the "Cheers" bar, where four arched windows of white granite grace the first-floor facade. (Courtesy BPL.)

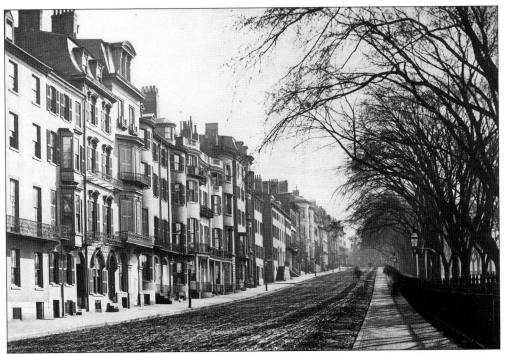

The steepest part of Beacon Street, from Charles Street to the State House, is the hill's oldest street, laid out in 1640 and named in 1708. It is pictured here in 1870. Generally, the higher the ascent up the street, the older the house. Early Bostonians believed that the summits of the hills provided the healthiest, most odor-free atmospheres. (Courtesy BPL.)

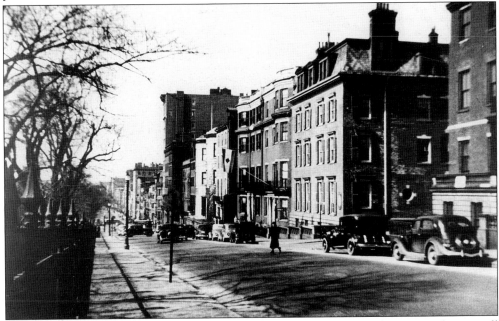

Beacon Street has become a heavily traveled street in the twentieth century, but it still maintains an air of elegance. The street is shown here in 1938, from the corner of Walnut Street. (Photograph by Paul Swenson, courtesy BPL.)

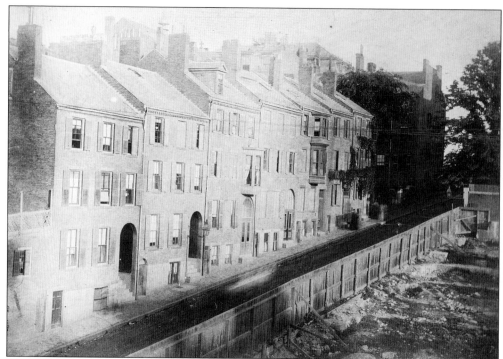

Temple Street from Derne to Mount Vernon, depicted here in 1886, was razed *c.* 1891 to make room for the expansion of the State House. Crossing the summit of Beacon Hill, Temple Street is named after Sir John Temple, who married a daughter of Governor Bowdoin. (Courtesy BPL.)

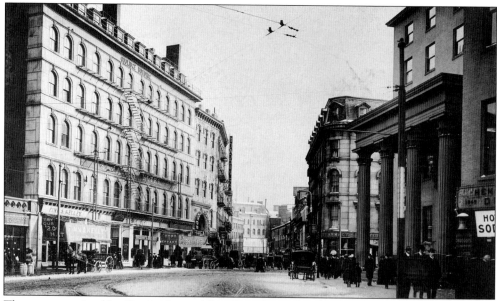

The area contained by Cambridge and Bowdoin Streets used to be called Bowdoin Square. In the third quarter of the nineteenth century, this was a handsome area with large and varied Bulfinch houses. Bowdoin Square has since been completely razed and today Bowdoin Street marks a distinct line between the new and the old Boston. (Courtesy BPL.)

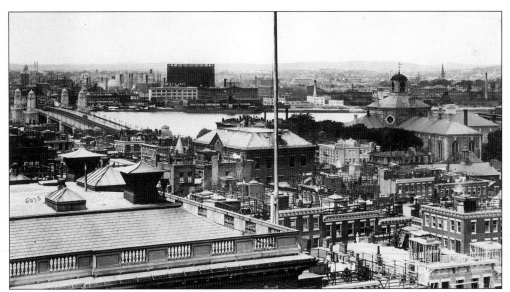

Taken after 1908, this photograph, looking over Beacon Hill toward Cambridge, reveals a view of the Suffolk County Jail and the Longfellow Bridge (in the background). The North Slope, most of which is shown here, was pasture land in the early eighteenth century. Later that century, the area developed as a region of disorderly houses and dance halls until it was cleaned up during the mayoralty of Josiah Quincy (1823–28). (Courtesy BPL.)

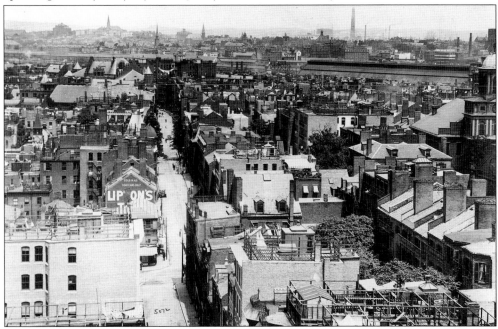

The North Slope and the packed streets of the West End with the West Church at the far right is pictured here after the 1880s. The residential immigrant neighborhood of the West End extended beyond the east side of Cambridge Street. Only the Massachusetts General Hospital (1821), the Charles Street Jail (1851), and a few other older buildings survive from its earlier days. The area was obliterated in the late 1950s in order to make room for luxury apartments. (Courtesy BPL.)

Two ladies rest for a quiet moment on the corner of Cambridge and North Russell Streets, c. 1895. (Photograph by the Halliday Historic Photograph Company, courtesy SPNEA.)

This view of the westerly corner of Cambridge Street and Ridgeway Lane in 1925 reveals a structure tagged for demolition in order to allow for the expansion of Cambridge Street. The advent of the automobile posed new problems for Boston city planners, resulting in the sacrifice of many old buildings to allow wider streets to be built. (Photograph by William Sumner Appleton, courtesy SPNEA.)

Ridgeway Lane set the stage for a lady harpist and a youngster playing the violin in 1904. The West Church (1806) lies at the end of the street in the distance. (Courtesy BPL.)

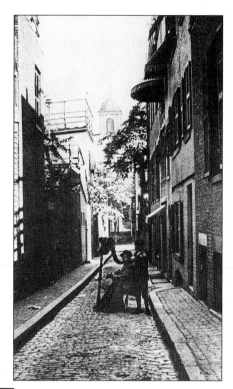

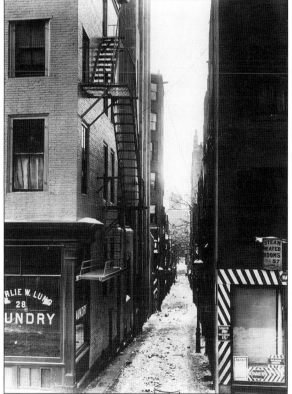

Ridgeway Lane and the West Church (rear) are shown here c. 1900. In the foreground lies a laundry business and a barber's shop below a boarding house on Derne Street, partially the site of today's Suffolk University's facade. (Courtesy BPL.)

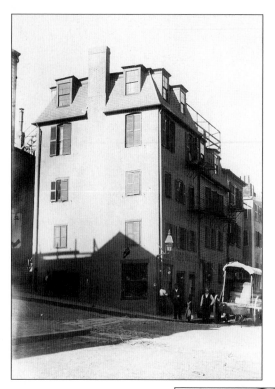

On the corner of Phillips and Anderson Streets in 1890, a few men tending to a horse-drawn delivery for the Hill Side Market pause for the camera. Small shops, markets, and businesses were scattered throughout the North Slope, Beacon Hill's nineteenth and early-twentieth-century working-class neighborhood. (Photograph by John W. Robbins, courtesy SPNEA.)

Businesses in 1909 on the residential Phillips Street used to keep their doors open at the ground level. Up the street at No. 66 was the home of Lewis and Harriet Hayden, supposedly a major stop on the Underground Railroad. During the nineteenth century, the North Slope became home to many African-Americans migrating from the south. Later that century, the area attracted waves of European immigrants as well. (Courtesy SPNEA.)

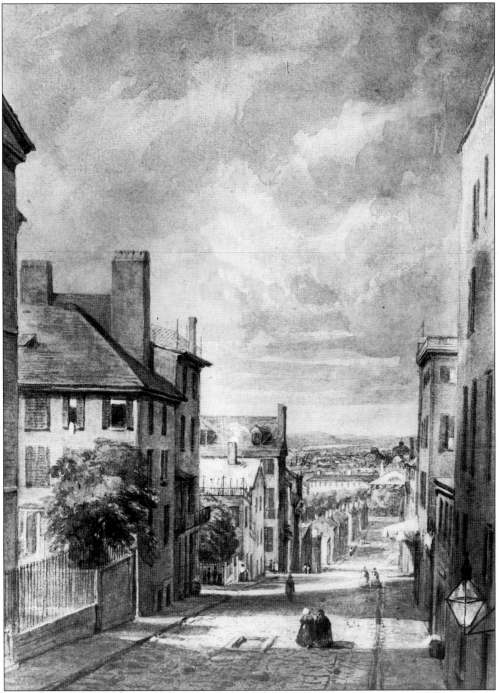

This painting of Anderson Street by Susanna Hickling Willard in 1850 depicts a very peaceful scene high up on the North Slope. (Reproduction of a watercolor on paper, courtesy SPNEA.)

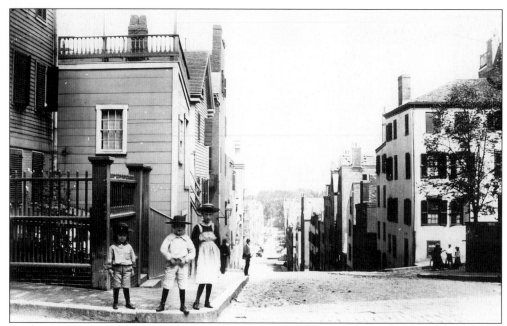

On the corner of Revere and Anderson Streets, three children pose in front of a wooden house in 1890. (Photograph by John W. Robbins, courtesy SPNEA.)

Photographed *c.* 1900, Sentry Hill Place, one of four intimate courtyards found off Revere Street on the North Slope, was built in the 1840s and initially housed artisans and tradesmen. The other three charming enclaves are Bellingham Place, Goodwin Place, and Rollins Place. (Courtesy BPL.)

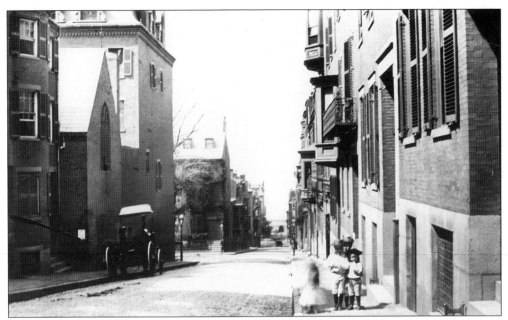

Laid out in 1803, Pinckney Street, shown here just above Louisburg Square in 1890, provides some excellent examples of late Federal domestic architecture. On the left stands the wall of a distinctive chapel designed by English architect Henry Vaughan. The Sisters of the Society of Saint Margaret, an Episcopal community, had been headquartered here since 1880 until just recently, when they moved to Roxbury. (Photograph by John Robbins, courtesy SPNEA.)

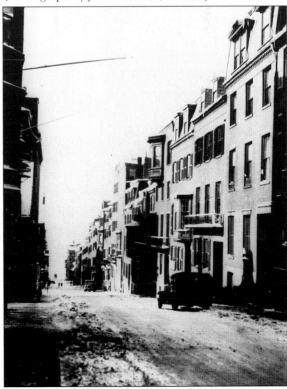

Looking down Pinckney Street from Anderson in 1928 reveals Pinckney as the clear dividing line between the North and the South Slopes. The North Slope stretches down the hill on the other side of the uninterrupted line of Pinckney Street houses to the right in this photograph. (Photograph by William Sumner Appleton, courtesy SPNEA.)

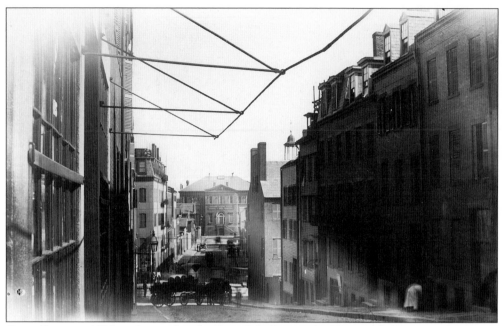

Grove Street in 1890 used to end at the Dental College in the West End. (Courtesy SPNEA.)

Grove Street in 1962 was dubbed the "Street of Fear" by a *Boston Herald* reporter after the Boston Strangler took one of his victims here. From 1962 to 1964, Albert de Salvo cruised all of Beacon Hill in his strangling spree. (Courtesy *Boston Herald*.)

Looking west from Grove Street in 1925 shows the widening of Cambridge Street. Laid out as a 12-foot wide highway in 1647, Cambridge Street was named in 1708 and widened in the 1920s. (Photograph by William Sumner Appleton, courtesy SPNEA.)

A window from the third story of the First Harrison Gray Otis House afforded this view over Beacon Hill of the flurried activity along Cambridge Street in 1925. (Photograph by William Summer Appleton, courtesy SPNEA.)

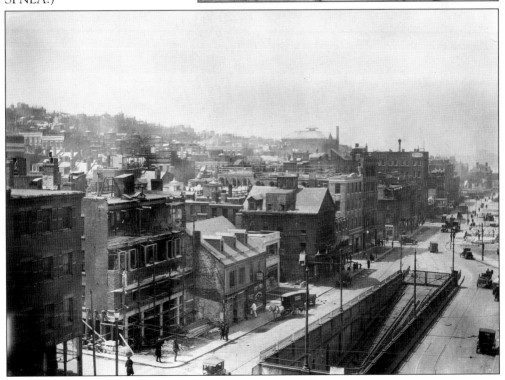

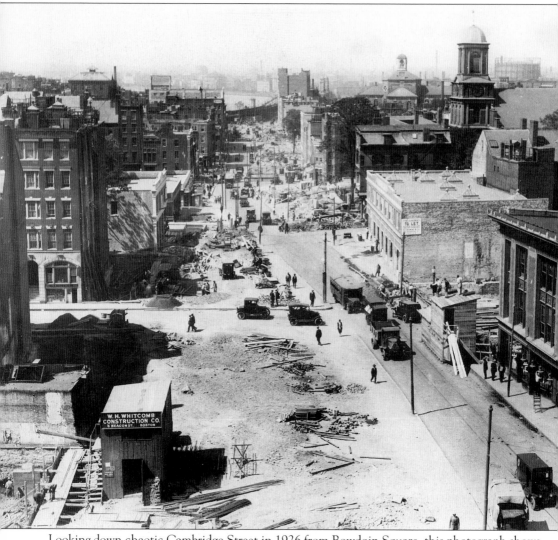

Looking down chaotic Cambridge Street in 1926 from Bowdoin Square, this photograph shows the boundaries of the old street and roughly those of the new one. It appears to have been widened almost three times its original width! (Courtesy SPNEA.)

Small shops lined the south side of Cambridge Street from Charles Street to West Cedar in 1910. This one on the corner advertises, among other products, 10¢ cigars and a soda fountain. (Photograph by the Boston Elevated Railway Company, courtesy SPNEA.)

A bread-delivery carriage heads to Charles Street from the Cambridge Bridge, c. 1927. (Courtesy SPNEA.)

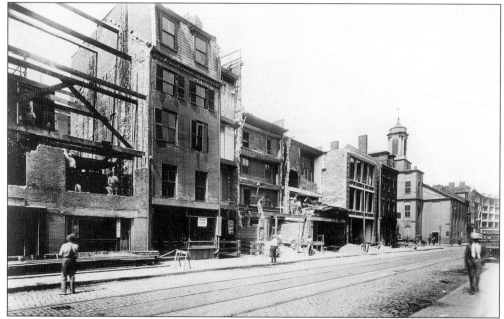

Charles Street, laid out in 1794, was widened 10 feet in the 1920s. Many facades were sliced off and replaced, and some buildings had to be entirely rebuilt. The Charles Street Meeting House (on the left) managed to escape a serious threat of demolition after members of the community raised enough money to move it 10 feet closer to the river. (Courtesy SPNEA.)

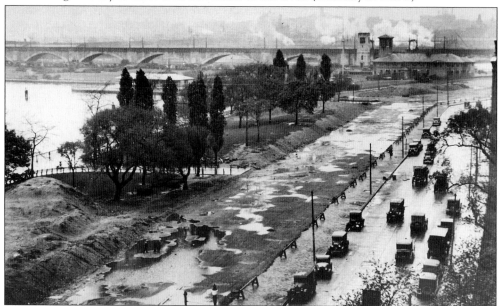

The widening of Charles Street in the 1920s completely altered the character of the west side. As horse-drawn carriages were gradually replaced by the automobile, many Boston thoroughfares, such as Beacon Hill's Charles and Cambridge Streets, were considered outdated and too narrow to accommodate two-way car traffic. Some condemned the street widening that moved the Charles Street Meeting House and flattened the old Eye and Ear Infirmary for a monstrous garage in 1922. (Photograph by Leslie Jones, courtesy BPL.)

This 1920s view of parked cars on lower Charles Street between the Common and the Public Garden provided a harbinger of the congested parking problems that would become part of Boston's future. (Photograph by Leslie Jones, courtesy BPL.)

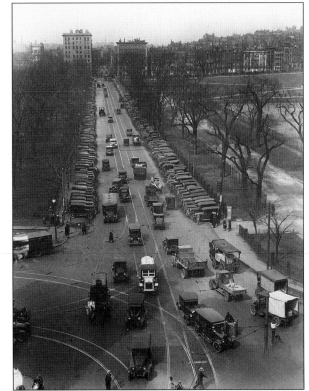

This *c.* 1920 photograph shows the trolley that used to run down Charles Street. (Photograph by Leslie Jones, courtesy BPL.)

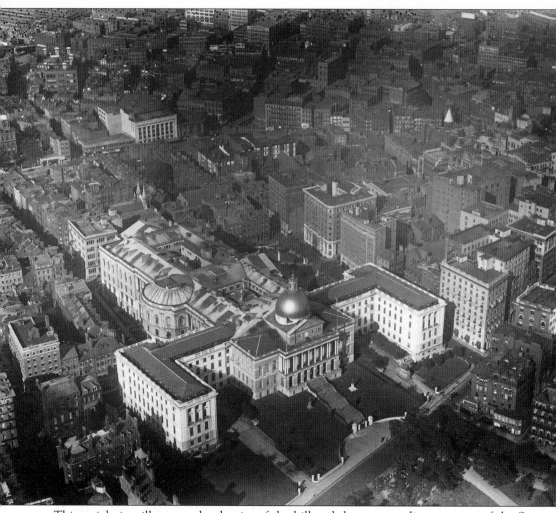

This aerial view illustrates the density of the hill and the commanding presence of the State House. (Photograph by Leslie Jones, courtesy BPL.)

Two
Public Buildings

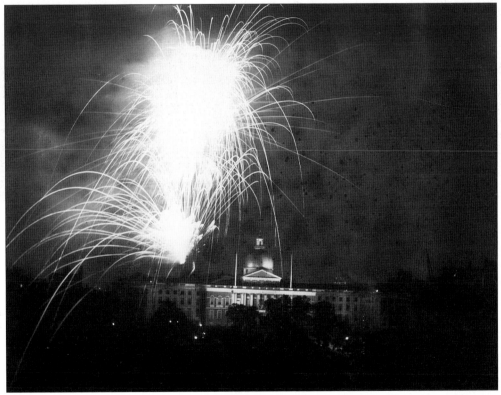

Boston's State House, at the summit of Beacon Hill on the former site of John Hancock's cow pasture, is illuminated by the glow of fireworks. The building, designed by Charles Bulfinch at the age of twenty-four, was completed in 1798. The design was derived from buildings Bulfinch had seen in London. Oliver Wendell Holmes once called the State House "the hub of the solar system," from which was derived Boston's current nickname, the "Hub." (Photograph by Leslie Jones, courtesy BPL.)

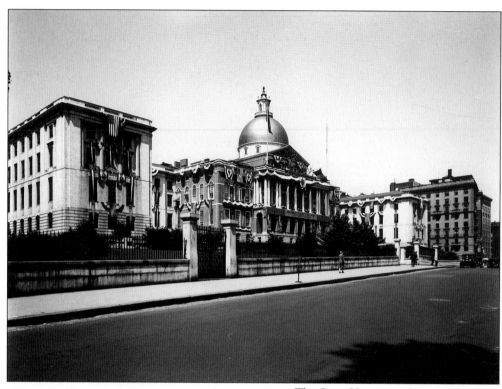

The State House in 1930 was bedecked with banners celebrating the city's tercentenary (1630-1930). New wings and many renovations have been completed throughout the years. Paul Revere & Sons covered the dome with copper in 1802, but in 1874 expensive 23-carat gold leaf was added over the copper-sheet base, a project that quickly generated controversy. (Photograph by Leon Abdalian, courtesy BPL.)

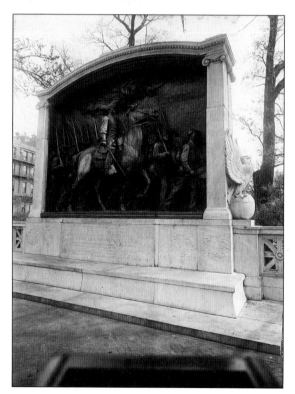

Sculpted by Augustus Saint-Gaudens, the Shaw monument of the 54th Regiment Memorial was dedicated in 1897 and stands opposite the State House on Beacon Street. A stop on the Black Heritage Trail, it commemorates Colonel Robert Gould Shaw and the volunteer, all-black 54th Regiment. Many of these brave soldiers were killed in their 1863 attack on Fort Wagner, South Carolina, as depicted in the 1989 film, *Glory*. (Photograph by Leon Abdalian, courtesy BPL.)

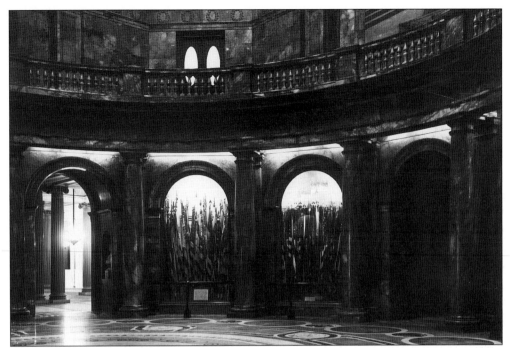

Inside the State House, the Hall of Flags, a rotunda surrounded by columns of Sienna marble, houses an impressive collection of more than four hundred battle flags carried by Massachusetts' soldiers from the Civil War to Vietnam. It is shown here in 1931. (Photograph by Leslie Jones, courtesy BPL.)

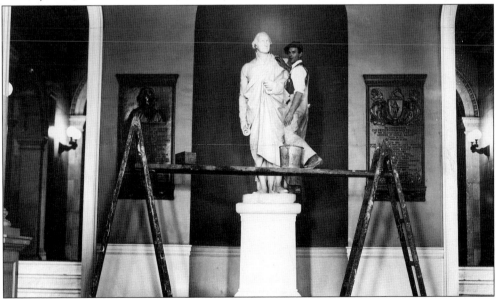

In January 1952, for the bicentennial of George Washington's birth, the first president's statue inside the State House was cleaned by Robert Guthrie. Sculpted in London by Sir Francis Chantery in 1826, the statue used to be in the Old State House. On the left lies a tablet of Charles Bulfinch and on the right is the Massachusetts state seal. (Photograph by Leslie Jones, courtesy BPL.)

Smith Court, located off Joy Street and shown here in 1890, was the religious, cultural, social, and educational gathering place for African-Americans in Boston in the early nineteenth century. In the left foreground lies the Abiel Smith School (1834), where black youths were schooled until 1855. Behind the school stands the African American Meeting House. The five residential structures completing the court are typical of those occupied by nineteenth-century black Bostonians. (Photograph by John W. Robbins, courtesy SPNEA.)

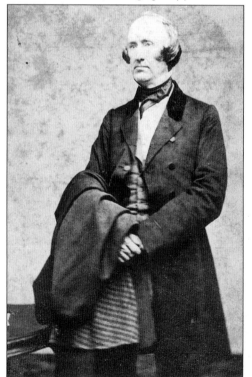

This 1860s photograph depicts William Lloyd Garrison (1805–1879), the leading abolitionist who gave many moving speeches in the African American Meeting House and edited *The Liberator* newspaper that incited Southern slaves to riot and revolt. The outspoken Garrison was mauled by a Boston mob in 1835 and thrown into jail for his own protection. (Cartes de Visites by Charles Taber & Company, courtesy BPL.)

The first African American Meeting House, shown here in the mid-1880s, was dedicated in 1806 and is the oldest black church building in America. It was designed to house a schoolroom for black children in the basement and a sanctuary on the first floor that served both as a place of worship and a meeting room. In 1832, this edifice was the birthplace of the Anti-Slavery society led by William Lloyd Garrison. (Photograph by the Halliday Historic Photograph Company, courtesy SPNEA.)

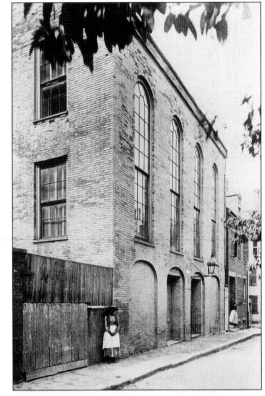

From 1898 to 1972, the African American Meeting House served as the Synagogue of Congregation Libavitz until it was acquired by the Museum of Afro-American History. The interior, shown here in 1937, has since been restored to its 1854 design. The Meeting House, school, and wooden frame houses are all sites along the Black Heritage Trail. (Photograph by Arthur Haskell, courtesy SPNEA.)

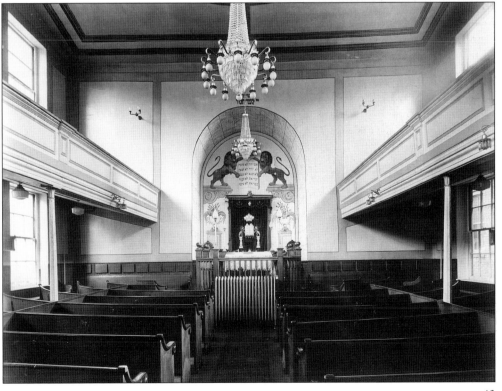

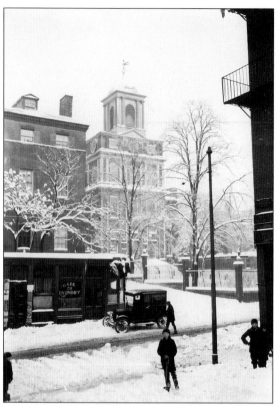

A young boy stops shoveling snow on Cambridge Street to pose for a photograph during the winter of 1923. Behind him lies the Old West Church to the right of the First Harrison Gray Otis House. The church was designed in the Federalist style by Asher Benjamin in 1806 and served until the Congregational parish dissolved in 1882. The building was used as the West End branch of the public library until 1960. (Photograph by William Sumner Appleton, courtesy SPNEA.)

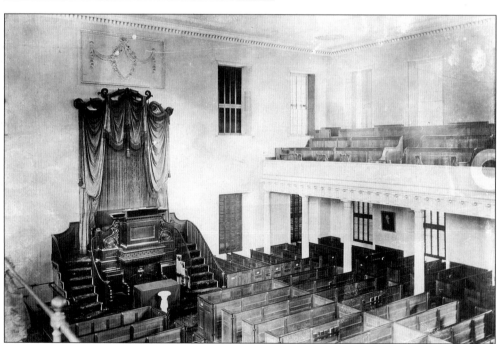

This pre-1897 photograph of the Old West Church's pulpit illustrates its once-glorious interior, before its transformation as a library. (Courtesy SPNEA.)

An old wood engraving depicts the Charles Street Meeting Place in 1853, which was called the Charles Street Baptist Church at the time. Completed in 1807 by Asher Benjamin, it was constructed for the white Boston Third Baptist Church. Boston's black Baptists were relegated to the balcony, but after this tradition was challenged by one of the church's abolitionist members, an enterprising group founded the first integrated church in America, today's Tremont Temple. (Engraving by Pilliner, courtesy BPL.)

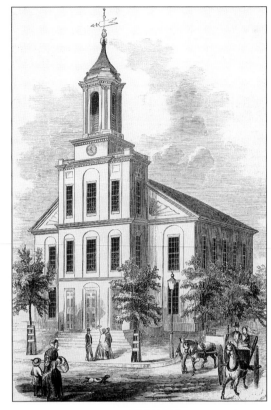

A few men rest on horse-drawn loads in front of the Charles Street Baptist Church in 1899. A monument along the Black Heritage Trail, the church was almost destroyed in the 1920s because of the proposal to widen Charles Street. Fortunately, the church was spared after community members raised enough money to move the building 10 feet closer to the river. (Courtesy SPNEA.)

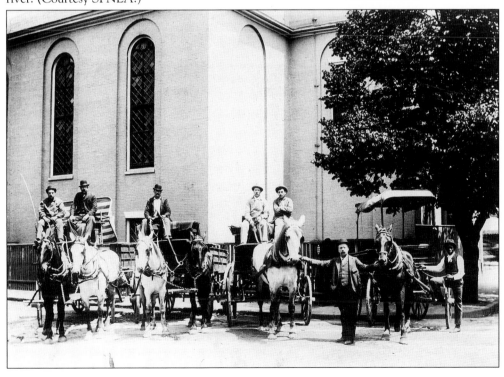

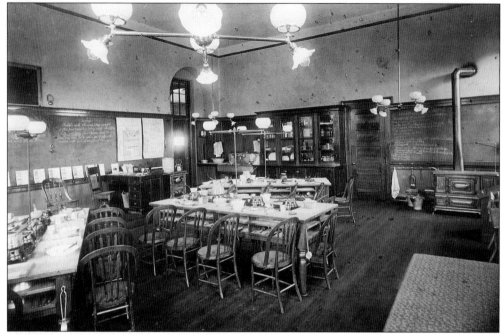

This home economics class took place in the Bowdoin School, located at 45 Myrtle Street (now apartments). This 1892–93 photograph was taken during the days when women were not allowed to be formally educated. They could, however, attend classes pertaining to domestic subjects. (Photograph by A.H. Folsom, courtesy BPL.)

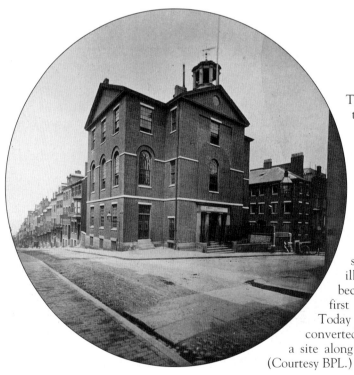

The Phillips School on the corner of Pinckney and Anderson Streets, pictured here in 1860, was built in 1824 and served as the white-only English High School until 1844. Subsequently, it operated as the Phillips Grammar School until 1861. In 1855, educational segregation was declared illegal and the school became one of the city's first integrated institutions. Today the building has been converted into condominiums and is a site along the Black Heritage Trail. (Courtesy BPL.)

An example of the Beacon Hill country-style architecture, the Convent of Saint Anne at 44–46 Temple Street was declared unsafe by the city in October 1952 and was later demolished. (Courtesy *Boston Herald*.)

This chapel at 27 Chestnut Street, constructed in 1918, was part of the Boston University School of Theology. In 1965, the building was converted to condominiums after surviving a threat of demolition. The imposing Gothic design distinguishes the structure from its architecturally unified surroundings of predominantly Federal and Greek Revival houses. (Courtesy *Boston Herald*.)

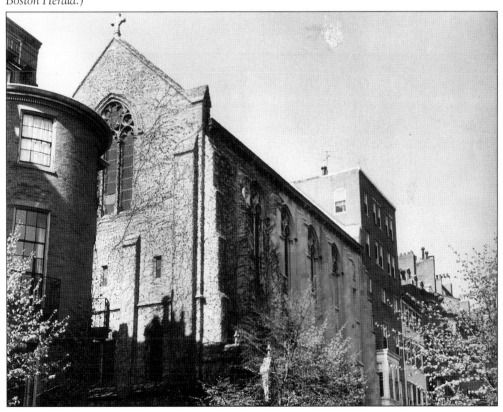

Shown here *c.* 1900, 57 Chestnut Street, on the corner of West Cedar, has been the Harvard Musical Association since 1892. It contains one of the country's oldest musical libraries, founded in 1837. (Courtesy *Boston Herald*.)

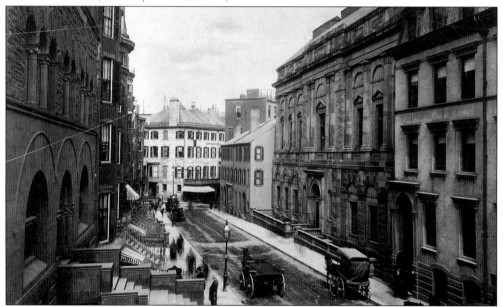

The Boston Athenaeum at 10 1/2 Beacon Street, shown here in 1890, was the center of Boston's cultural life in the nineteenth and early twentieth centuries. This outstanding private research library and art gallery was founded in 1807 and has occupied this building since 1847, when it was built by Edward Clarke Cabot. The art collection here helped to establish the Boston Museum of Fine Arts, lending the new art institution many of its first exhibits. (Courtesy BPL.)

The Irene F. Sanger School on 76 Chestnut Street was probably a school exclusively for women, as this c. 1880 photograph suggests. (Courtesy SPNEA.)

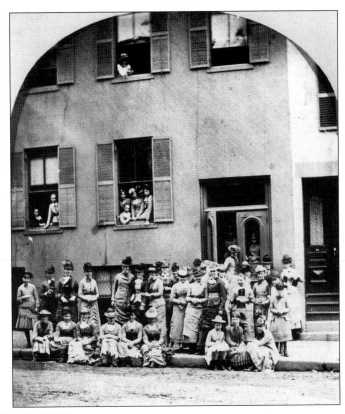

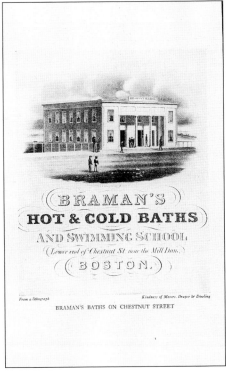

A "Braman's Baths" drawing on this Chestnut Street flat suggests that a bath house existed in these quarters in the nineteenth century. During this time, public baths were experiencing a renaissance in Europe. (Courtesy SPNEA.)

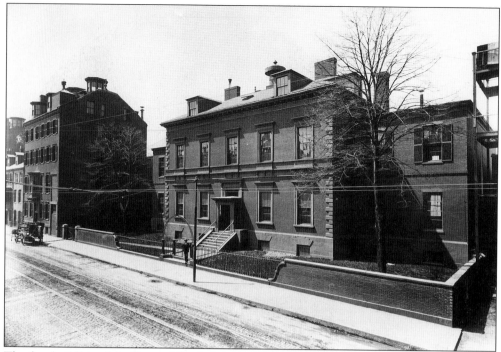

The first building of the Eye and Ear Infirmary, shown here c. 1899, stood initially on Charles Street. (Photograph by Baldwin Coolidge, courtesy SPNEA.)

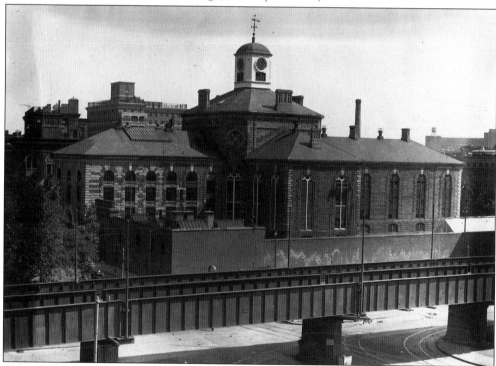

The Suffolk County Jail stands on Charles Street without its wall in August 1930. (Photograph by Leslie Jones, courtesy BPL.)

A view of Temple Street in the direction of Derne Street in 1860 reveals the Old Grace Church (Methodist) on the right, built in the Gothic Revival style and demolished in the 1960s to make room for a new Suffolk University building. At the end of the street lies the old reservoir, where today one can find a parking garage beneath Bulfinch Park. (Photograph by Josiah J. Hawes, courtesy BPL.)

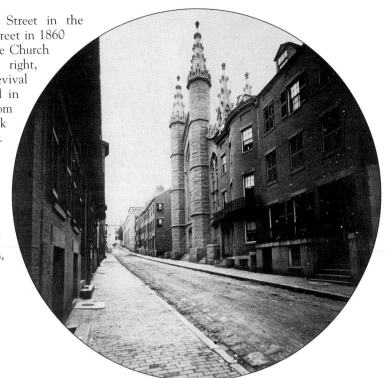

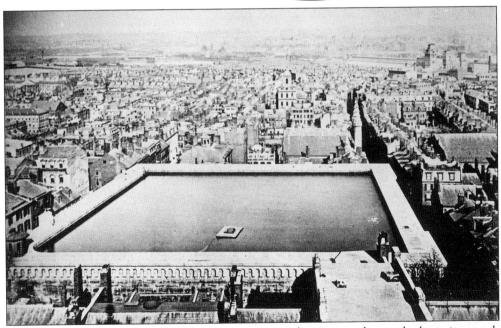

The Beacon Hill Reservoir, seen here with its mammoth granite arches in the late nineteenth century, was designed by William S. Whitehall in 1848. It held the city's water supply until the 1880s, when it was destroyed to make room for the State House's eastern addition between Hancock and Temple Streets. The Old Grace Church soars toward the sky on the left side of the photograph. (Courtesy BPL.)

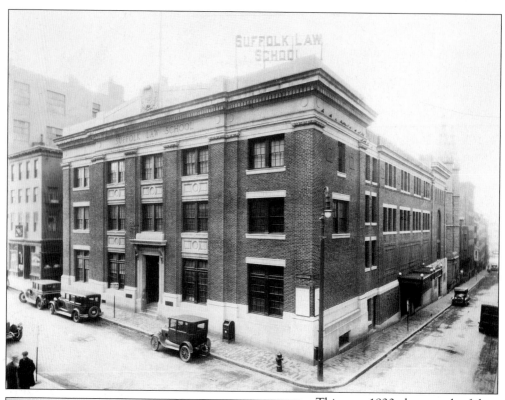

This post-1920 photograph of the corner of Derne and Temple Streets shows the new Suffolk Law School. (Courtesy SPNEA.)

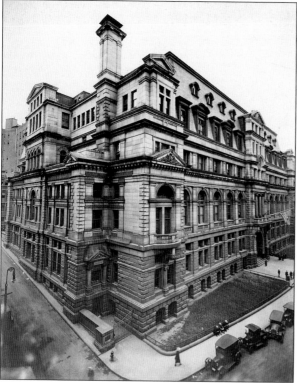

The Suffolk County Courthouse, depicted here in 1920, was built for $4 million in 1885. Half of Pemberton Square, which used to be a residential oasis of row houses surrounding an island of trees, was razed to clear ground for the project. (Courtesy BPL.)

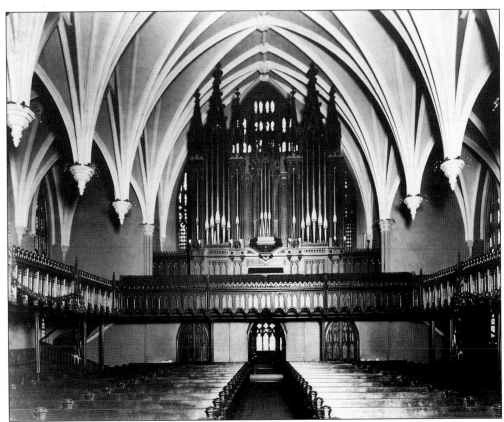

The Church of the New Jerusalem on Bowdoin Street was demolished in 1964. (Courtesy SPNEA.)

The Church of Saint John the Evangelist was built in the Gothic Revival style in the early 1830s by Solomon Willard. Built originally for the Congregational Society, the church was pastored by Reverend Lyman Beecher, father of Harriet Beecher Stowe, until members dispersed around 1863. It is shown here in 1860 when it was called the Bowdoin Square Church. (Photograph by Josiah J. Hawes, courtesy BPL.)

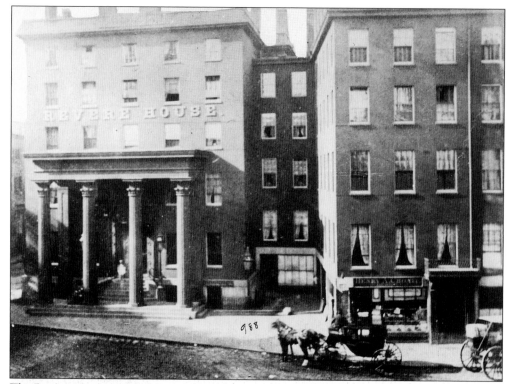

The Revere House, a Greek Revival building once located in Bowdoin Square, was designed in 1847 by William Washburn and was considered one of the finest hotels in America. Its floors were laid with marble tiles and mirrors reflected the beauty of the main entrance. The hotel was demolished in 1919 and is presently the site of a government office building. It is shown here c. 1890. (Courtesy BPL.)

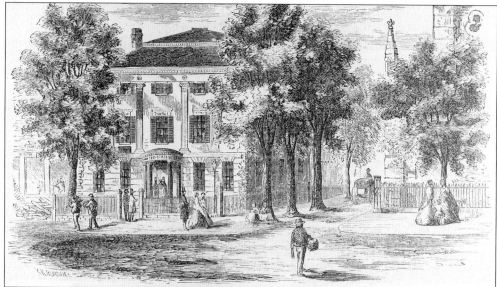

The U.S. Court House also used to be located in Bowdoin Square, as this early engraving illustrates. (Courtesy BPL.)

Three
Private Residences

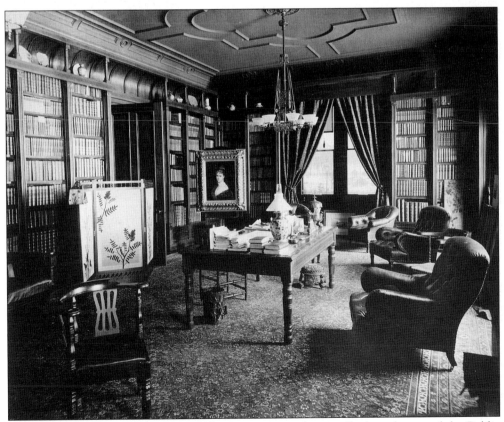

The window of this private library in a Beacon Street house affords a glimpse of the Public Garden during a winter in the late nineteenth century. (Courtesy BPL.)

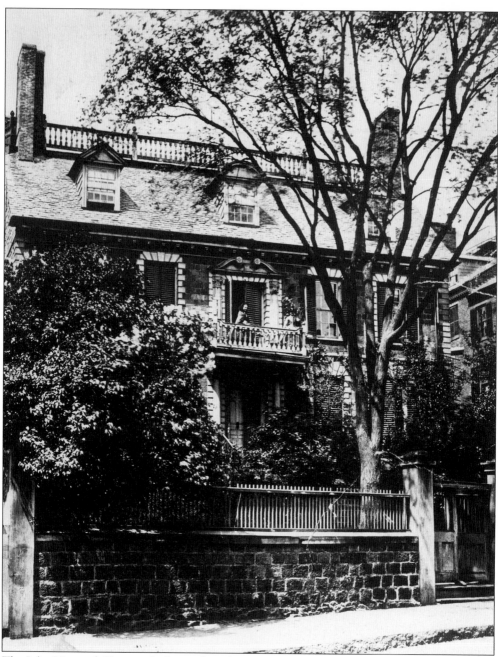

The John Hancock House, which stood on the grounds of today's State House, is shown here in a rare 1860 photograph. This Colonial mansion, built of stone by Hancock's affluent uncle in 1737, was one of the most elegant in its day, commanding a magnificent view of the Common. The Hancocks owned the land on which would later stand the State House, part of the reservoir, Hancock Street, and Mount Vernon Place. Also on his land were stables, a coach house, and a summer house. (Courtesy BPL.)

This broadside, published to save the John Hancock House by T.O.H.P. Burnham in 1863, illustrates one of Boston's first preservation efforts. Unfortunately, despite a vigorous protest, the house was demolished in 1863 in order to make room for the new State House. (Courtesy SPNEA.)

BOSTONIANS!
SAVE THE
OLD JOHN HANCOCK MANSION
THERE IS TIME YET, ALTHOUGH THE WORK OF
DEMOLITION HAS COMMENCED

It is a question of some perplexity to decide how far it is wise or proper for the city government or for individuals to interfere to prevent the act of modern vandalism which demands the destruction of this precious relic; for that it is destroyed, in effect, if removed, we conceive admits of no question. Will it, or will it not, be a mitigation of the public disgrace to establish the house itself elsewhere as a perpetual monument of the proceeding.

Without wishing in the least degree to discourage the public spirit and the patriotism of those gentlemen in the City Council who are seeking at this moment to do the best thing they can for the preservation of the house, we still think it right that one preliminary appeal should be made to the present owners. They are gentlemen of wealth, they have made an honest purchase, and of course may plead that they have a right to do what they will with their own. It is with full recognition of their rights in this respect, and withal in the utmost kindness to them, that we would admonish them how dearly is purchased any good thing which costs the sacrifice of public associations so dear and so noble as those that cluster around the Hancock House.

These purchasers must at any rate be prepared to hear, during the whole of their lives and that of their remotest posterity, so long as any of them may live in the elegant modern palaces which shall supplant the ancient structure, the frequent expression of public discontent. Argument may show them blameless, but sentiment will ever condemn the proceeding in which theirs will be perhaps the most innocent, but nevertheless the most permanent part. It is not often that an opportunity is given to men of wealth to earn a title to public gratitude by an act of simple self-denial. Such an opportunity falls to the pet of the purchasers of this estate.

EUROPEAN MAGAZINE.

JOHN HANCOCK Esqr.

Published Nov. 5, 1783, by J. Fielding, No. 23, Pater-noster Row.

This engraved portrait of John Hancock (1737–1793) was published in the *European Magazine* in 1783. The first to sign the Declaration of Independence, Hancock was a Boston patriot and a leader of the American Revolution. In his house Hancock entertained such notable dignitaries as Washington, Lafayette, and D'Estaing. (Courtesy BPL.)

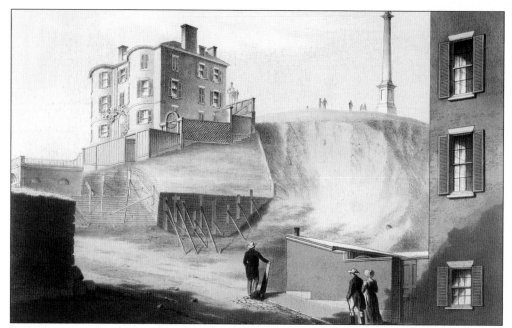

Beacon Hill and the Old Thurston House are depicted here *c.* 1811 from Bowdoin Street. William Thurston, a successful lawyer, built his house *c.* 1800 on land purchased from the Hancock estate. However, it was later declared unsafe and destroyed in 1855. (Reproduction from a watercolor by J.R. Smith, courtesy BPL.)

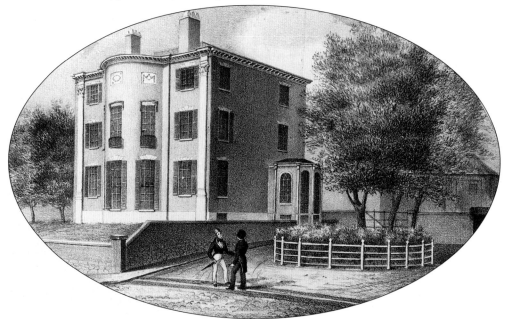

Created in 1825–36, this lithograph illustrates the Jonathan Mason House on Mount Vernon, fronting Walnut Street. The house was an 1802 Bulfinch design that was razed in 1837 after the land was sold to make room for house lots at 59–67 Mount Vernon Street. Mason was one of the original Mount Vernon Proprietors and a wealthy local merchant who became a U.S. Senator. (Print by Pendleton's Lithography, courtesy BPL.)

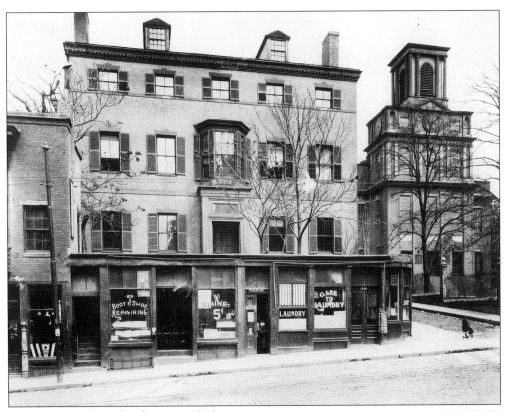

Harrison Gray Otis's first house in 1916 stands behind small businesses fronting Cambridge Street, to the left of the West Church. The mansion was designed in 1795–96 by Charles Bulfinch, whose American Federal domestic architecture expressed the ideals of the wealthy aristocratic culture that sprang up after the Revolution. He designed all three of Otis' houses in Beacon Hill. (Photograph by Frank Cousins, courtesy SPNEA.)

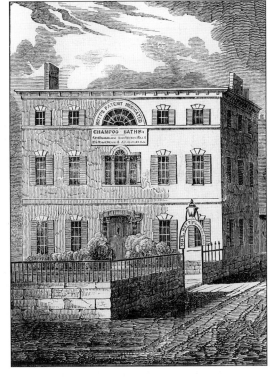

This woodcut illustration provides the earliest view of Harrison Gray Otis' first house. It was the frontispiece of *The Ladies' Medical Oracle; or, Mrs. Mott's Advice to Young Females, Wives, and Mothers* (1834). Toward the end of the nineteenth century, Otis's home became a rooming house in the decaying West End. The Society for the Preservation of New England Antiquities purchased it in 1916, and today it is the only free-standing late-eighteenth-century mansion in Beacon Hill. (Courtesy SPNEA.)

The second Harrison Gray Otis House at 85 Mount Vernon Street is also a Bulfinch design, with its upper stories adorned by four Corinthian pilasters. It was built 1800–1802 as the second home for Otis, and is shown here in 1938. One of the few detached mansions on the hill, it is still maintained as a private residence. (Photograph by Paul Swenson, courtesy BPL.)

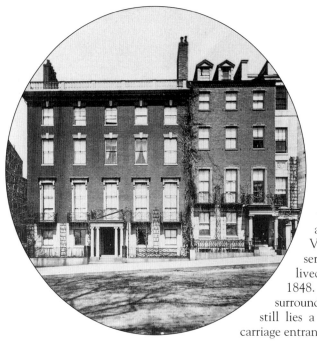

The third Harrison Gray Otis House at 45 Beacon Street was built 1805–1806 by Bulfinch. Otis was a prosperous politician/lawyer and one of the original Mount Vernon Proprietors; he eventually served as Boston's third mayor. He lived here from 1806 until his death in 1848. The property was originally surrounded by gardens, and off to the west still lies a cobbled driveway intended as a carriage entrance. (Courtesy BPL.)

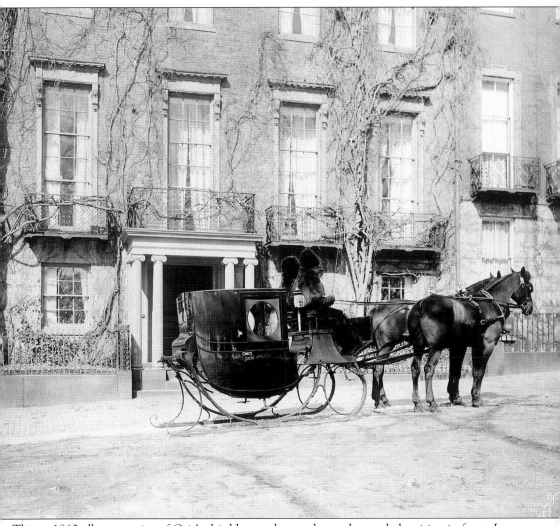

This *c.* 1860 albumen print of Otis's third house shows a horse-drawn sled waiting in front. In 1828, the mansion was the scene of the owner's inauguration as mayor of Boston. Today the mansion houses the American Meteorological Society. (Photograph by Thomas Marr, courtesy SPNEA.)

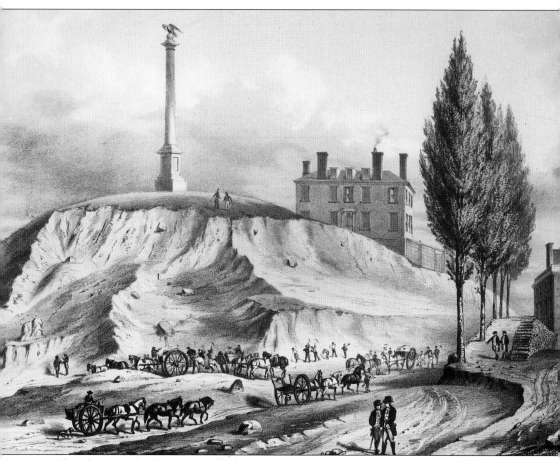

This photograph of Beacon Hill from Mount Vernon Street provides a view of the Thurston House sitting at the summit of the hill, c. 1811. (Reproduction from a watercolor by J.R. Smith, courtesy BPL.)

The Amory-Ticknor House, a Bulfinch design, was erected in 1804 and still stands on the corner of Beacon and Park Streets, across from the State House. This edifice used to house the country's largest private library. Today the house is sadly bereft of its early impressiveness and elegance, but is still a worthy monument. (Courtesy BPL.)

George Ticknor (1791–1871) was a well-known Harvard professor and benefactor of the Boston Public Library. He wrote the great work *Ferdinand and Isabella* in 1837 and first published *The Atlantic Monthly*, still considered to be one of America's leading magazines. This photograph was taken in the 1850s. (Courtesy BPL.)

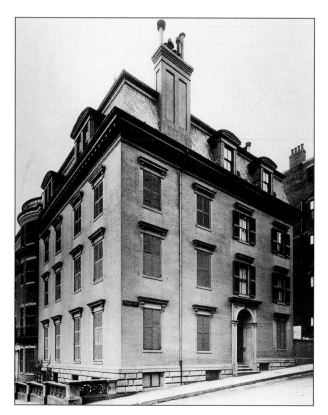

The Phillips House, Beacon Street's first brick house, on the corner of Beacon and Walnut Streets, was built in 1804 by John Phillips, Boston's first mayor. Designed by Bulfinch and photographed here in the late nineteenth century, the house's flat facade and recessed, arched doorway are typical of the Federal style. The original entrance was on Beacon Street. This was the birthplace of Mr. Phillips's son, Wendell Phillips (1811–1884), the famous American orator. (Courtesy BPL.)

This c. 1860 portrait of Wendell Phillips depicts one of the foremost abolitionists in the United States. He advocated the disunion of free and slave states and welcomed the American Civil War. During the war, Phillips criticized President Abraham Lincoln for delaying emancipation. Because of his outspoken views, Phillips was often faced with ridicule and the threat of mob violence. In 1870 he was the Labor party and Prohibitionist candidate for governor of Massachusetts. (Carte de Visites by Allen & Horton, courtesy BPL.)

The David Sears House at 42 Beacon Street was built in 1819 according to the design of Alexander Parris. In 1831, Sears, under pressure of escalating real estate prices, doubled the size of the house, making it the most expensive dwelling of its day in Boston. It became the Somerset Club in 1872; the site is also the former home of artist John Singleton Copley. (Courtesy BPL.)

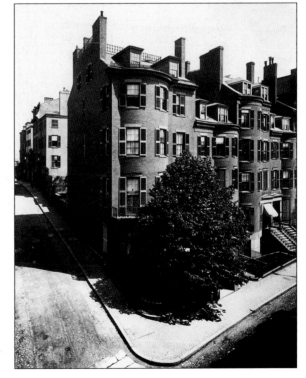

The Old Chase House on the corner of Beacon and Bowdoin was built c. 1843 and was photographed here c. 1885. (Photograph by Baldwin Coolidge, courtesy BPL.)

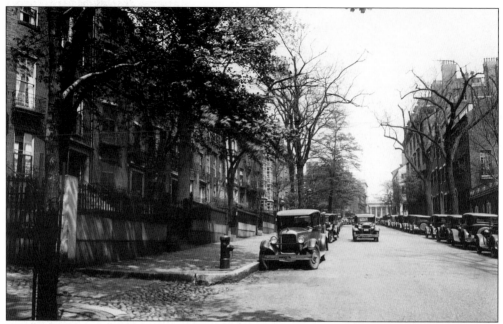

In the left corner of this photograph lies 83 Mount Vernon Street, once the home of William Ellery Channing (1780–1842), one of the foremost theologians of his time and leader of American Unitarianism. On the right are converted stables built by Bulfinch where American artists Maurice and Charles Prendergast executed many paintings in the late nineteenth century. (Photograph by Leon Abdalian, courtesy BPL.)

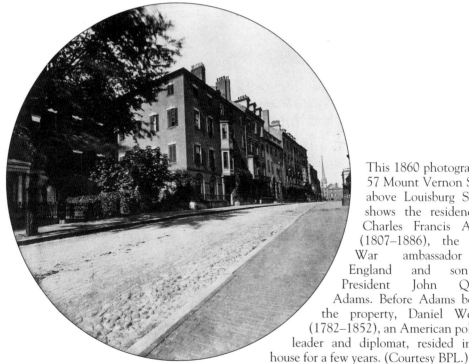

This 1860 photograph of 57 Mount Vernon Street above Louisburg Square shows the residence of Charles Francis Adams (1807–1886), the Civil War ambassador to England and son of President John Quincy Adams. Before Adams bought the property, Daniel Webster (1782–1852), an American political leader and diplomat, resided in the house for a few years. (Courtesy BPL.)

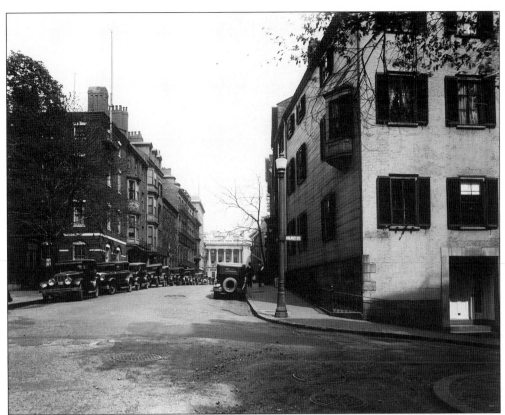

At 55 Mount Vernon Street is the Nichols House (on the left), built in 1804 for Jonathan Mason. On the right, the John Callender House at Walnut Street was the among the first houses built on Mount Vernon Street (c. 1802). (Photograph by Leon Abdalian, courtesy BPL.)

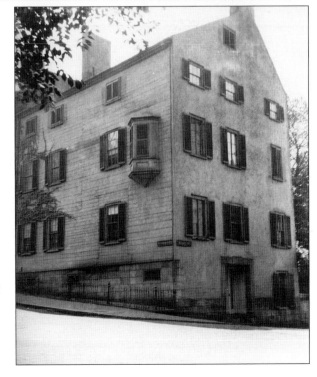

The John Callender House still stands on the corner of Walnut and Mount Vernon Streets. It is one of the few extant free-standing mansions built in the earliest years of the nineteenth century. (Photograph possibly by Allen Chamberlain, before 1925, courtesy SPNEA.)

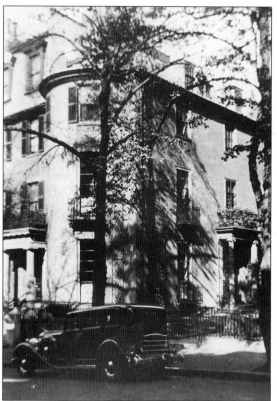

Designed probably by Bulfinch and photographed here in 1938, 29A Chestnut Street was the home of Shakespearean actor Edwin Booth (1833–1893). It was built *c.* 1800 and is the only house on the street with a main entrance facing on the side, complete with lawn and garden (most houses have their gardens in the rear). (Photograph by Paul Swenson, courtesy BPL.)

Louisburg Square has been the favorite haunt of many literary figures. Those who have lived here include William Dean Howells, editor and author of the *Atlantic Monthly,* and author Louisa May Alcott. Julia Ward Howe, who wrote the "Battle Hymn of the Republic," resided nearby on Mount Vernon Street. Among the many frequent literary visitors were Ralph Waldo Emerson, Edgar Allan Poe, Henry Wadsworth Longfellow, and Charles Dickens. (Courtesy BPL.)

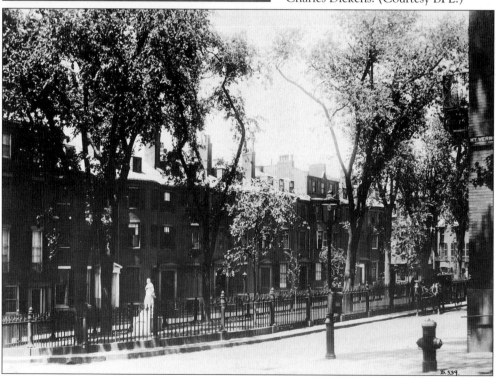

The second house from the left, 10 Louisburg Square, is where Louisa May Alcott resided after reaping the financial success from *Little Women*. (Courtesy BPL.)

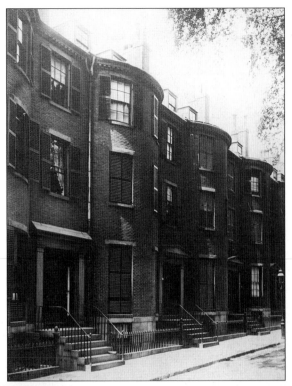

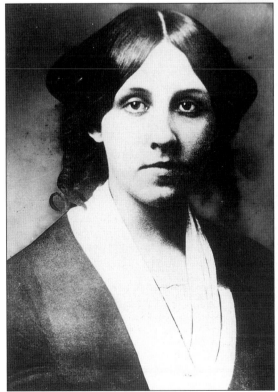

This photograph of Louisa May Alcott (1832–1888) portrays the writer who contributed to the *Atlantic Monthly* but became famous for her novel, *Little Women*, the proceeds from which enabled her to pay off all her family's debt. Louisa Alcott also took an active part in the temperance and women's suffrage movements. She died two days after her father, Amos Bronson, who was in his own right an accomplished philosopher, educator, and writer. (Courtesy BPL.)

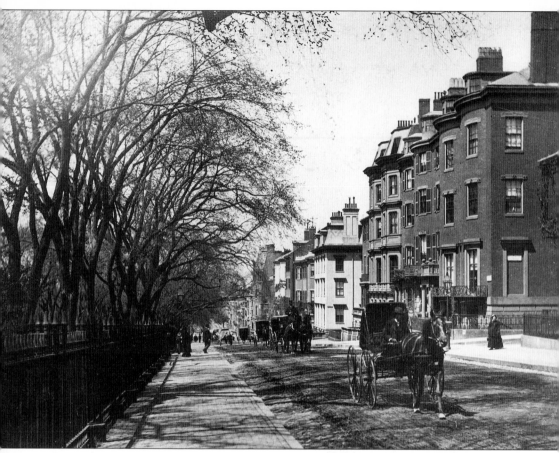

Horse-drawn carriages clop their way up Beacon Street in a view looking down from the corner of Joy Street. The home on the corner here, 34 1/2 Beacon Street, was the home of Frederic Tudor, also known as the "Ice King," who, a few years after the American Revolution, pioneered the business of shipping ice from Boston to the south and as far away as the West Indies and Calcutta. (Courtesy BPL.)

This photograph shows 63, 62, and 61 Beacon Street in 1915. The building at 61 Beacon Street was the home of Christian Herter, a governor of Massachusetts and the secretary of state under President Eisenhower. The many lavender window panes date between 1818 and 1825, when the glass faded to its present color and was consequently deemed defective. Today these purplish panes, seen scattered throughout windows on the hill, are cherished by property owners and admired by hill strollers. (Photograph by Thomas Marr, courtesy BPL.)

Just below Spruce Street on Beacon Street, four houses command an elegant presence. The house at 53 Beacon (extreme left), built in 1855, contains a grand circular staircase. The building at 50 Beacon was the site of Boston's first resident, William Blackstone, a reverend and hermit who fled the Old World for the isolation of the new in the 1620s. (Photograph possibly by Josiah J. Hawes, courtesy SPNEA.)

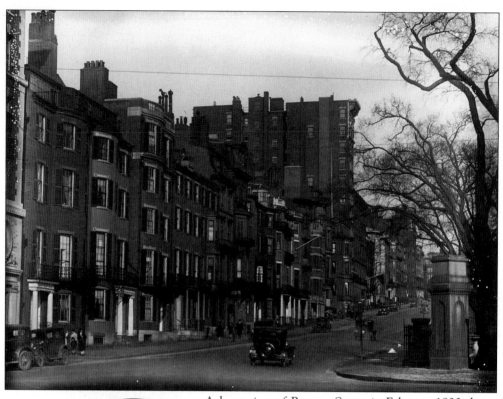

A long view of Beacon Street in February 1930 shows two double houses. The bow-front double-facade houses in mirror image became a popular architectural style in early Beacon Hill, and later in surrounding Boston. At the beginning of the slope, 63 and 64 Beacon Street, built in 1821, combined the late Federal and early Greek Revival styles and are today the property of the King's Chapel. Midway up the slope lies another double house at 54 and 55 Beacon, designed by Asher Benjamin in 1808. (Photograph by Leslie Jones, courtesy BPL.)

William Hickling Prescott (1796–1859), depicted in this 1850 lithograph, was a distinguished historian and authority on Spanish history who lived at 55 Beacon Street. Among his written works were *The Conquest of Mexico* and *The Reign of Ferdinand and Isabella*. (Lithograph by F. D'Avignon from a Brady daguerreotype, courtesy BPL.)

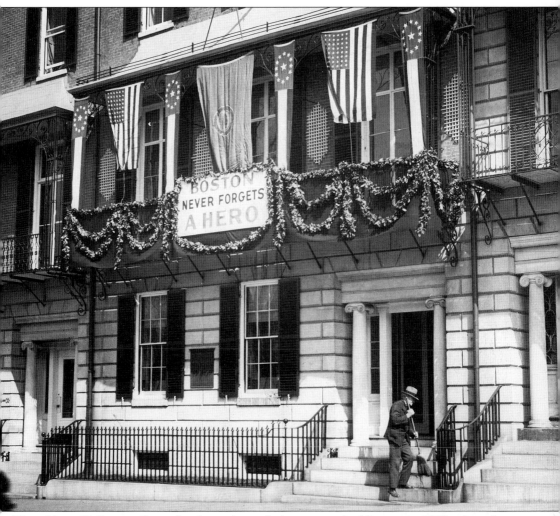

The address 33 Beacon Street has been the park department building since 1908, when the Parkman family bequeathed it to the city. It is shown here all decked out in anticipation of the Bremen flyers' visit to Boston in May 1928. In earlier years, it was the home of George F. Parkman, the son of Dr. George Parkman, whose macabre murder shook the city of Boston and resulted in a highly publicized trial. Dr. George Parkman, a Boston Brahmin, was murdered on November 23, 1849, at the Boston Medical College (now the site of Massachusetts General Hospital). Parkman's friend and colleague John Webster, distraught and embarrassed over money owed to Parkman, delivered a fatal blow to Parkman's head with a large piece of wood. As part of his cover-up, Webster then dissected the body and hid the parts throughout his laboratory. John Webster was found guilty with malice and hung the next year, in August 1850. (Courtesy *Boston Herald*.)

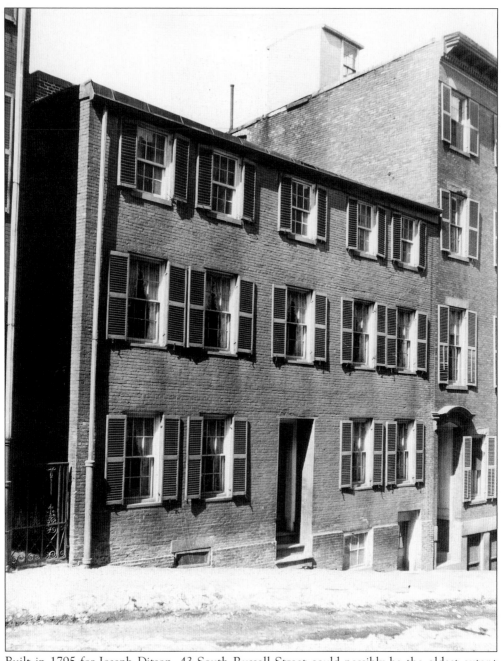

Built in 1795 for Joseph Ditson, 43 South Russell Street could possibly be the oldest extant house on Beacon Hill. The plain exterior of this three-story brick house defies its elegant and tasteful interior. Initially it functioned as a double house, and at one time it operated as a bakery. This is a pre-1931 photograph; presently, it is a single-family house with the original stove in the basement. (Courtesy SPNEA.)

A horse-drawn carriage clops past the Adams house at 40 Myrtle Street, which was destroyed in June 1920. (Courtesy SPNEA.)

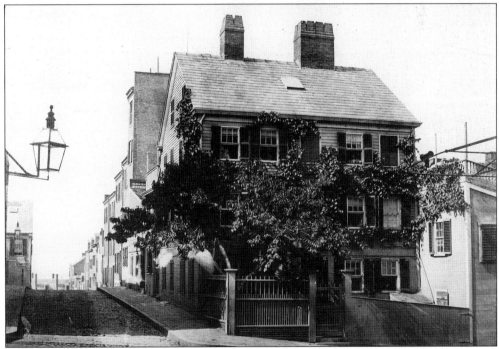

This late 1860s photograph shows the Winter House, once located on the northwest corner of Myrtle and Anderson. Built in 1826 by Frances B. Winter, the single-family house surrounded by a fenced-in garden has since been demolished. Myrtle Street was the site of the eighteenth-century ropewalk. (Courtesy SPNEA.)

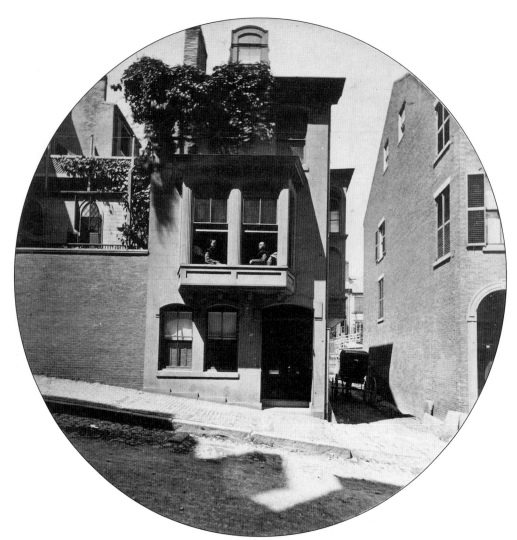

The house of Dr. Buckminster Brown, opposite Ashburton Place at 59 Bowdoin Street in 1860, was formerly a stable. It has since been razed. This fashionable area in and around Bowdoin Square was once home to many notable Bostonians, including architect and Mount Vernon Proprietor Charles Bulfinch. (Photograph by Josiah J. Hawes, courtesy BPL.)

An unidentified house on Charles Street is shown at a time when the street was primarily residential. (Courtesy BPL.)

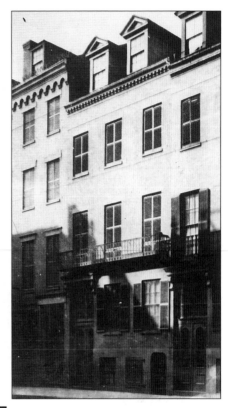

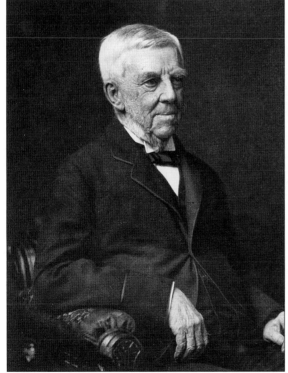

Oliver Wendell Holmes (1809–1894) lived for a time on Charles Street. This 1894 photogravure depicts the essayist, who published a series of articles in the *Atlantic Monthly*. It was in that magazine that Holmes coined the term "Boston Brahmin." In addition to being one of the most famous American writers of his day, he was also a well-known poet and professor of anatomy at Harvard Medical School. (Photogravure by A.W. Elson & Company, courtesy BPL.)

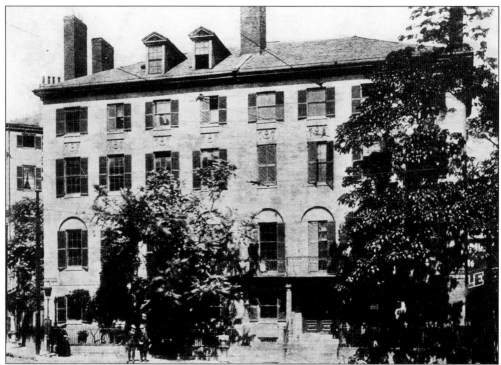

This large granite double house, built c. 1816 by Samuel Parkman, a wealthy merchant, stood for years at the western end of Bowdoin Square. The building has since been razed and is today the site of a commercial structure that bears Parkman's name. (Courtesy BPL.)

Beacon Hill is abundant with hidden gardens. A pilgrimage to the many beautiful gardens on the hill is an annual event, organized under the auspices of the Beacon Hill Garden Club. Beacon Hill garden owners and horticulturists open their colorful floral sanctuaries for the enjoyment of many who tour the hill's gardens. (Photograph by Leslie Jones, courtesy BPL.)

Four

The Boston Common
and Public Garden

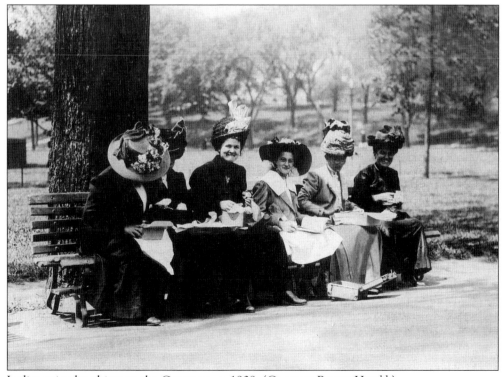

Ladies enjoy lunching on the Common, c. 1908. (Courtesy *Boston Herald.*)

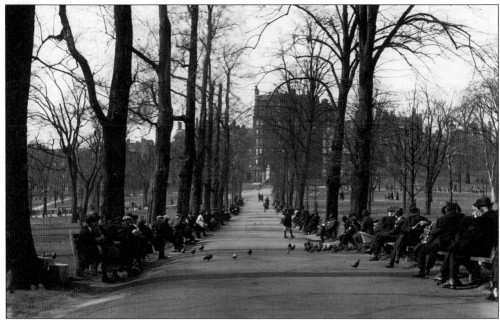

America's oldest park, the Boston Common, attracts city-dwellers and pigeons during a perfect spring day, *c.* 1900. These 48 acres were purchased in 1634 as common land for the townspeople, serving successively in the early days as a cow pasture, a military training field, and a public hanging site. During the Revolution, British regulars camped and trained here and were eventually buried on these grounds after the disastrous Battle of Bunker Hill. (Courtesy BPL.)

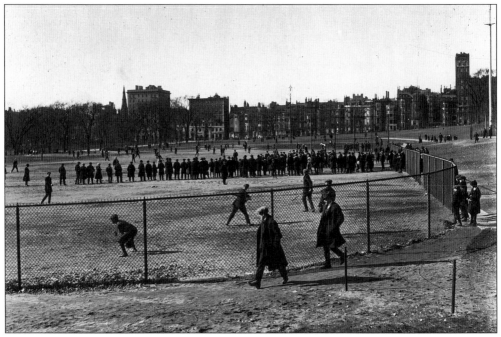

The Boston Common comes alive every year during the first spring ball game. This one took place on March 19, 1922. (Photograph by Leslie Jones, courtesy BPL.)

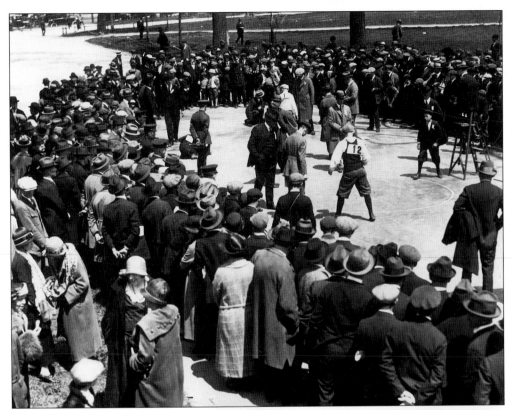

The *Herald-Traveler* used to organize marble tournaments on the Charles side of the Common. (Photograph by Leslie Jones, courtesy BPL.)

Photographer Leslie Jones climbed a tree for the best shot of the marble contest in 1924. (Courtesy BPL.)

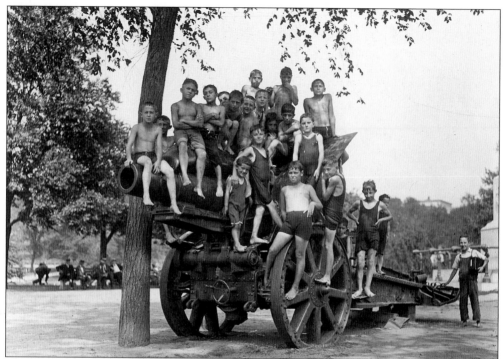

Young children pose on a captured German gun on the Common. (Photograph by Leslie Jones, courtesy BPL.)

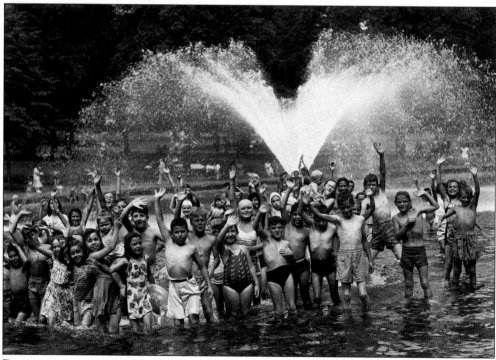

During a warm summer day, children cool off in the fountain of the Common's shallow Frog Pond. (Photograph by Leslie Jones, courtesy BPL.)

An acrobatic performance on the Boston Common by the Boston Fire Department impresses spectators. These city greens have operated as an active outdoor stage for centuries. (Photograph by Leslie Jones, Courtesy BPL.)

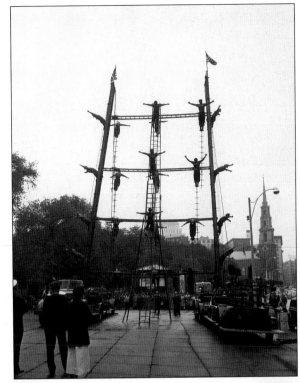

People used to stop and listen to the radio on the Common. (Photograph by Leslie Jones, courtesy BPL.)

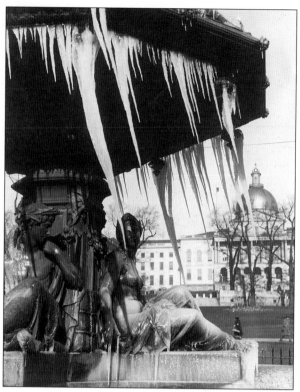

The Common is adorned with approximately sixteen statues as part of its public art program. The bronze Brewer Fountain was a gift from Beacon Hill resident Gardner Brewer, who brought it home from the Paris Exposition of 1867. It was sculpted by Paul Lienard in 1855. Here, Lienard captured the ideal of classic human beauty in the mythological figures of the sea nymph Galatea and her lover Acis. (Photograph by Leslie Jones, courtesy BPL.)

The Common's greens are covered with a blanket of snow during the winter. This public park, where young Ralph Waldo Emerson used to walk his cows, was declared off-limits to the animals in 1830. By the 1840s and '50s, Boston had become a city with gardens. (Photograph by Leslie Jones, courtesy BPL.)

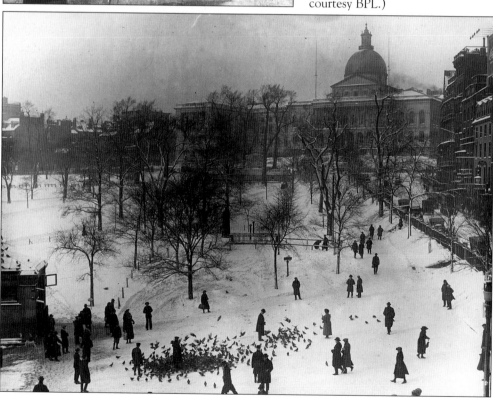

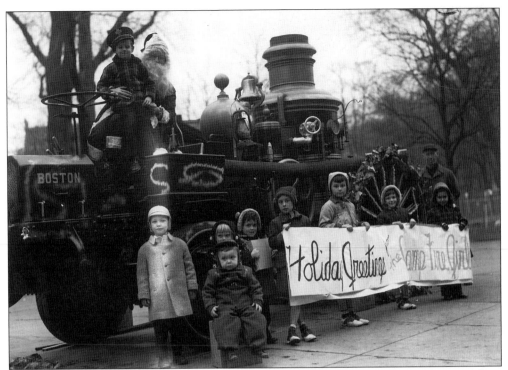

The Camp Fire Girls wish strollers well in the Common during the holidays as they pose for a picture on an old steam engine. (Photograph by Leslie Jones, courtesy BPL.)

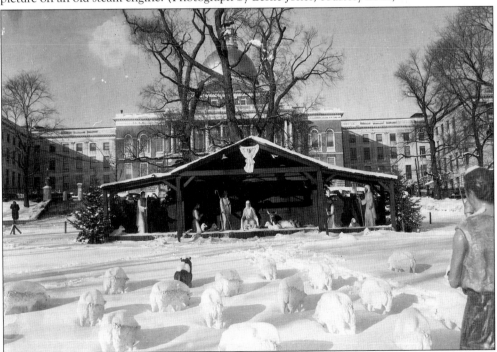

A Christmas nativity scene adorns the wintry grounds of the Common in front of the State House in December 1954. (Photograph by Leslie Jones, courtesy BPL.)

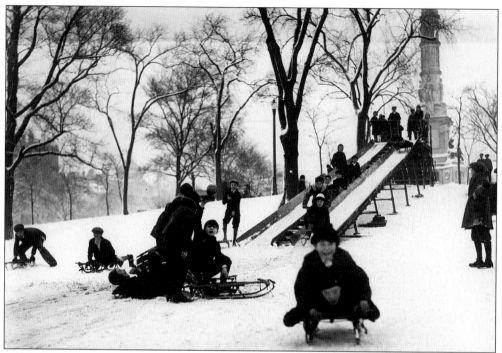

Sledding on the Common, photographed here in December 1930, has been a favorite winter pastime of young boys for centuries. (Photograph by Leslie Jones, courtesy BPL.)

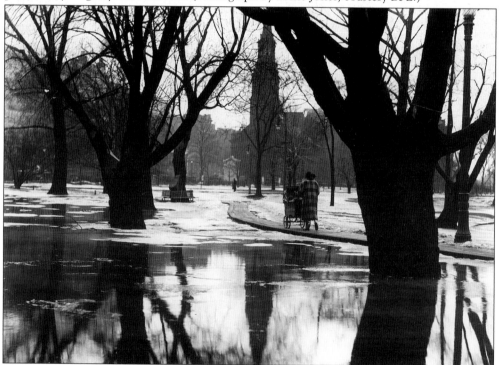

A lady strolls with her baby carriage through the Common during an early spring thaw. (Photograph by Leslie Jones, courtesy BPL.)

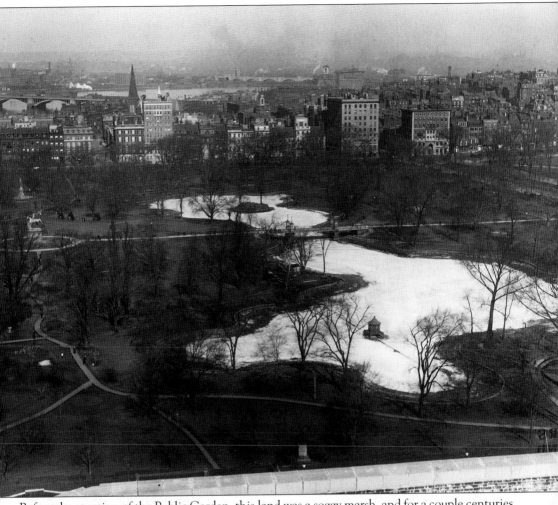

Before the creation of the Public Garden, this land was a soggy marsh, and for a couple centuries during high tide, it was a playground where Bostonians could swim, boat, fish, or skate. Some of these traditions still continue in this beautifully peaceful oasis surrounded by the city of Boston. Half the size and age of the Common, the lagoon was photographed here from the Hotel Statler (the site of today's Four Seasons), facing Beacon Street in March 1927. (Courtesy BPL.)

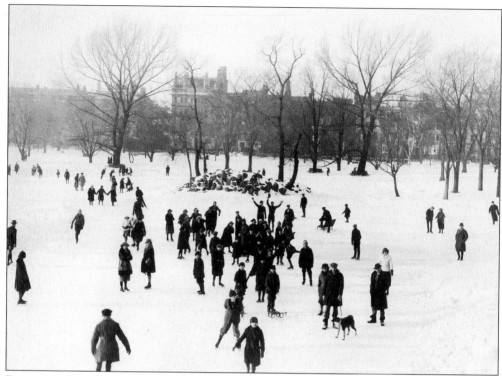

Bostonians have long enjoyed enjoy winter sports on the lagoon in the Public Garden. This photograph was taken in February 1923. (Photograph by Leslie Jones, courtesy BPL.)

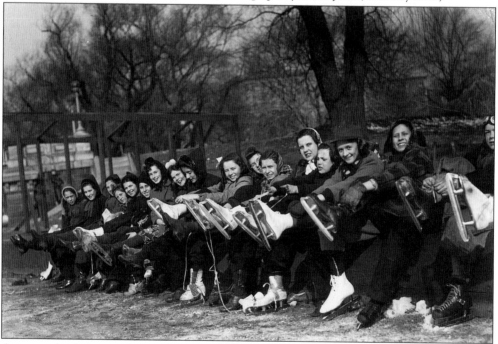

A group of girls lace up for ice-skating, an old winter tradition on these grounds. (Photograph by Leslie Jones, courtesy BPL.)

88

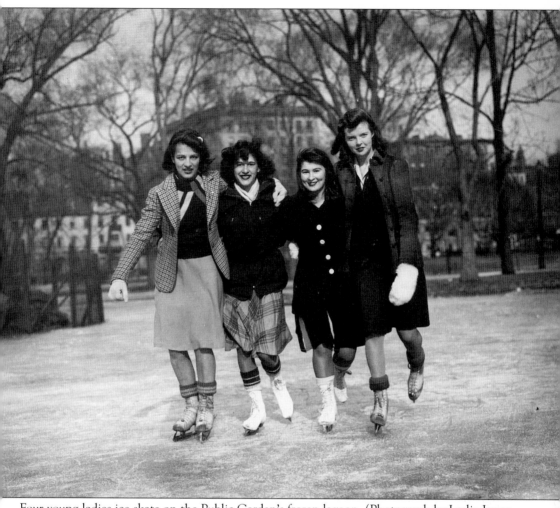

Four young ladies ice skate on the Public Garden's frozen lagoon. (Photograph by Leslie Jones, courtesy BPL.)

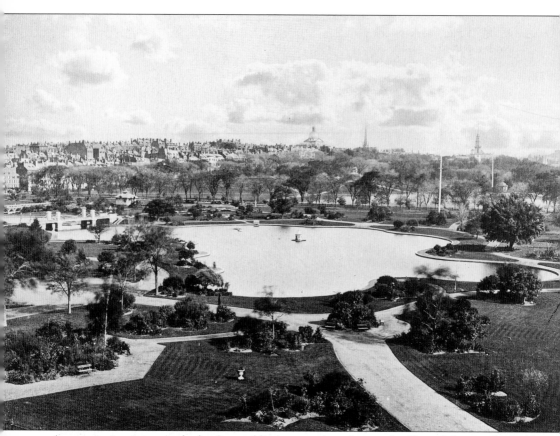

A panoramic view reveals the first public botanical garden in the United States, the Public Garden, *c.* 1892. The city bought these 24 acres in 1824 for $55,000. In 1859, architect George F. Meacham received $100 for his design of this oasis of trees, flowers, public art, and swan paddle boats in the middle of Boston proper. After raising the lower portion of the Garden to the level of the surrounding streets, Meacham removed an old greenhouse and enclosed the area with iron fences. He then created an English-style garden surrounding a 3-acre lake within the park. Soon after, a mini-bridge spanned the lagoon, and statues, fountains, and flowers adorned the Public Garden. Swan boasts have operated here since 1877. (Courtesy BPL.)

Charles Sumner's statue proudly stands in the Public Garden during a cold winter with the Park Street Church in the distance. Sculptor Thomas Ball completed the commission in 1878, after Anne Whitney's earlier proposal for a Sumner tribute was rejected because of her gender. Sumner (1811–1874) served in the U.S. Senate for twenty-two years and advocated emancipation and free speech. (Photograph by Leslie Jones, courtesy BPL.)

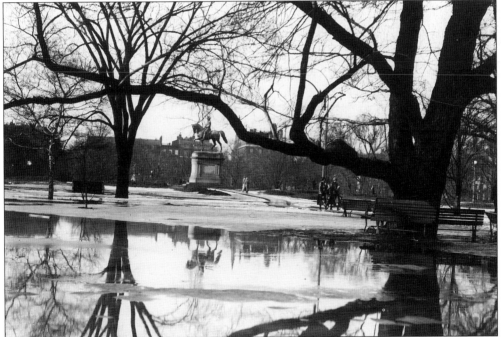

The Public Garden thaws out while people stroll around the grounds. The statue of Revolutionary War commander-in-chief and first president George Washington (1732–1798) was sculpted by Thomas Ball and placed in the Garden in 1869. (Photograph by Leslie Jones, courtesy BPL.)

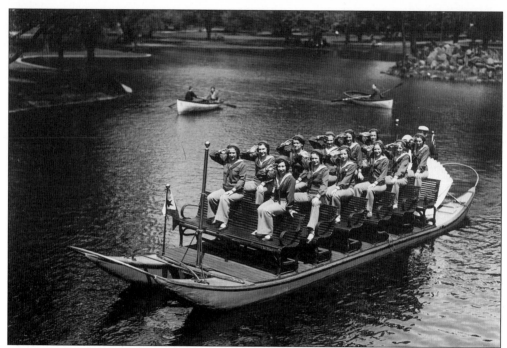

Women sailors salute from the swan boats in May 1937. (Photograph by Leslie Jones, courtesy BPL.)

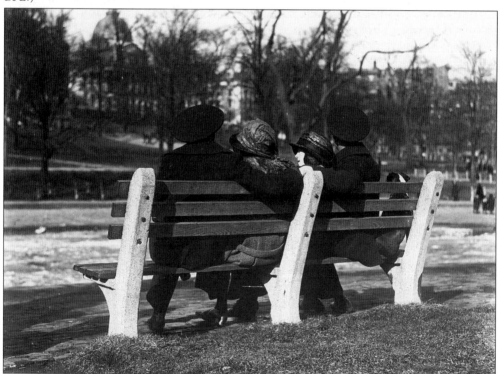

Sailors share a bench with their lady friends and a dog. (Photograph by Leslie Jones, courtesy BPL.)

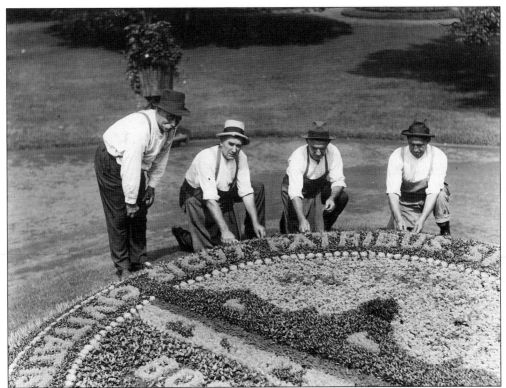

The main attraction of the Public Garden is its flora and fauna. Every year the Boston Parks and Recreation Department plants thousands of colorful flowers in artistic clusters, as illustrated in this early twentieth-century photograph. (Photograph by Leslie Jones, courtesy BPL.)

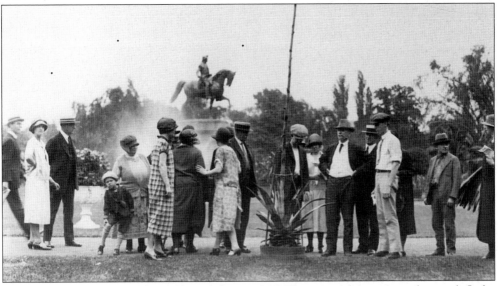

A century plant blooms in the Public Garden in 1925. This tropical American plant with fleshy leaves and greenish flowers was mistakenly thought to bloom only once a century, and consequently it made local news when it blossomed. It actually blooms once in ten to twenty years and then dies. (Photograph by Leslie Jones, courtesy BPL.)

Children have long enjoyed fishing in the Public Garden. (Photograph by Leslie Jones, courtesy BPL.)

The Public Garden's ducks have held a special place in the hearts of children since Robert McCloskey's 1941 *Make Way for Ducklings*. The tale of Mr. and Mrs. Mallard's search for water and a place to raise their ducklings leads them to the island in the Garden's lagoon where they live happily ever after. In 1987 this children's classic was commemorated with a bronze sculpture of the duck family near the Charles Street entrance to the Garden. (Photograph by Leslie Jones, courtesy BPL.)

Five
Social and Political Beacon Hill

Ben Turpin (1874–1940), a vaudeville film star, visits Boston in October 1921. Being stopped by the Boston police officer gave Turpin's famous crossed eyes a chance to work. He was one of the first slapstick comics in silent films and is seen here at the Boston Police Station in Pemberton Square. (Photograph by Leslie Jones, courtesy BPL.)

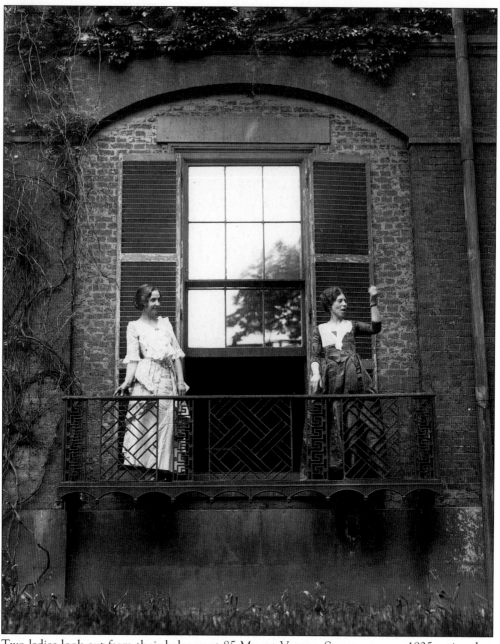

Two ladies look out from their balcony at 85 Mount Vernon Street on a pre-1925 spring day.
(Courtesy SPNEA.)

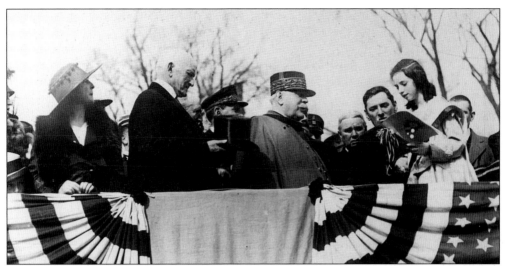

In 1917 General Joffre came to Boston and visited the Common, where Mayor Curley's daughter gave the war hero a large sum of money from New England children for French orphans. Joffre was a French marshal and World War I commander of the Allied armies in France. (Courtesy BPL.)

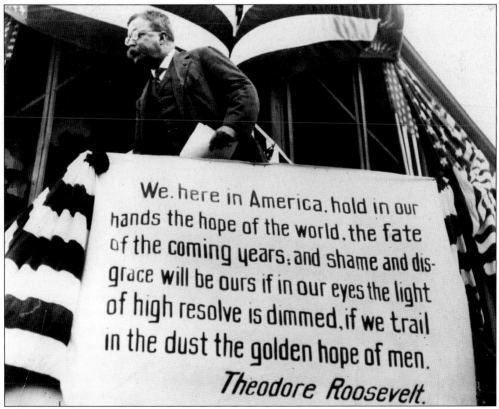

Theodore Roosevelt arrived in Boston during World War I on a special train and carried his big stick sign. On May 2, 1918, he visited 11 Beacon Street, the site of the Naval Service Club, where he praised the navy. (Courtesy BPL.)

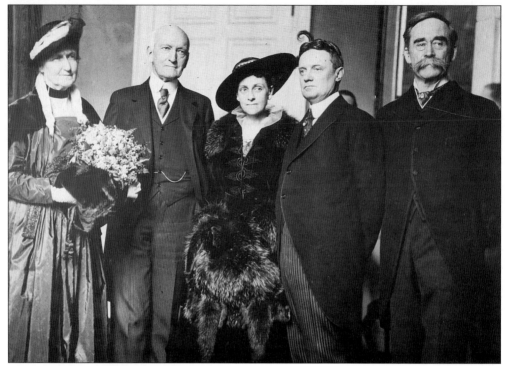

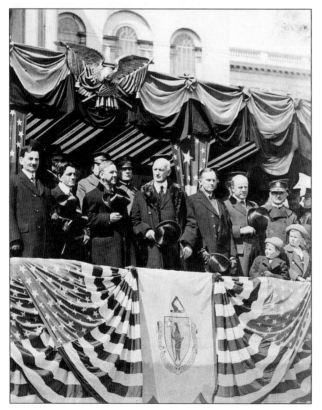

Samuel McCall, elected to serve as governor for three consecutive terms, was inaugurated on January 14, 1917. From left to right are: Mrs. Samuel W. McCall, Governor McCall, Mrs. Charles S. Whitman, Governor Whitman (of New York), and Rear Admiral Robert Peary (retired). (Courtesy BPL.)

Governor McCall reviews the Patriot's Parade in April 1918 in front of the State House. The city greeted "Boston's own" national regiment of trained soldiers who had been prepared to be called into duty during World War I. Over 350,000 spectators enjoyed the parade with Governor McCall. (Courtesy BPL.)

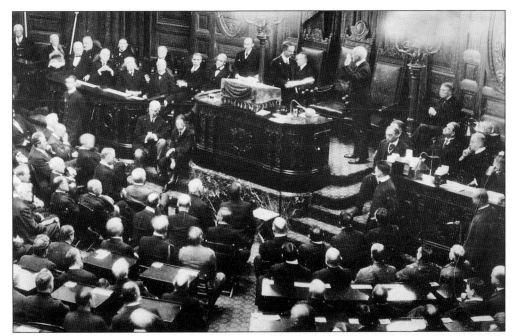

In June 1918, Governor McCall was sworn into office for a third term. He is seen here taking the oath in the Massachusett's House of Representatives. (Courtesy BPL.)

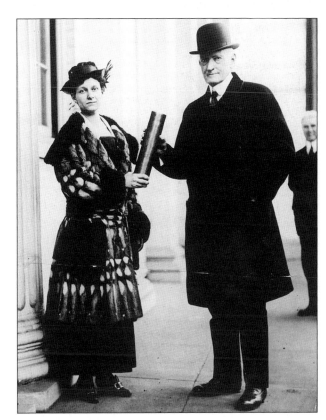

In March 1918, Mrs. Sherburne, wife of Colonel Sherburne, presented the first shell fired at the Germans by members of the former National Guard of Massachusetts. (Courtesy BPL.)

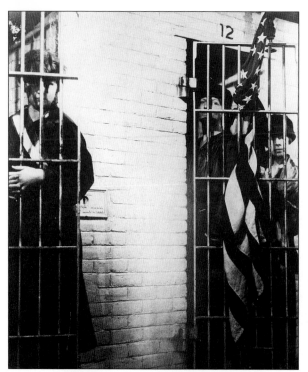

A group of local suffragists, photographed here possibly in the Charles Street Jail, were thrown behind bars in 1919. The right for women to vote in federal elections was not granted in all the states until the nineteenth amendment was passed in 1920. Until then, many women were willing to suffer the consequences of championing their worthy cause. (Courtesy SPNEA.)

The suffragists held a placard addressed to President Woodrow Wilson in 1919. (Courtesy SPNEA.)

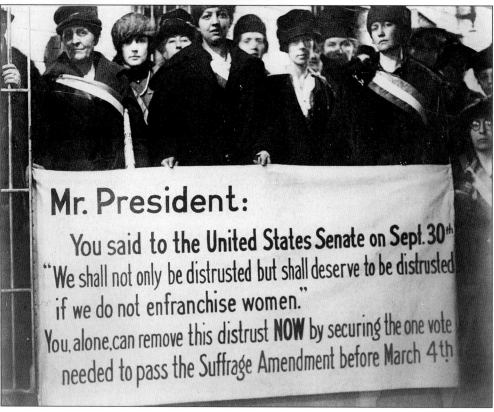

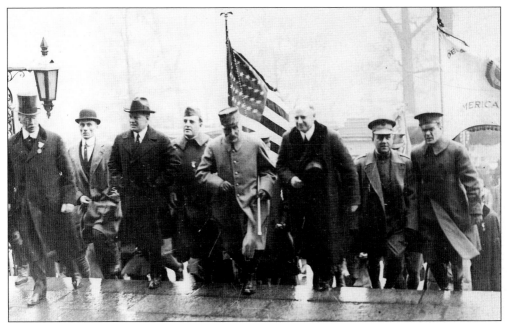

General Foch arrived at the State House with Governor Alvan F. Fuller and his party in 1922. Foch was commander-in-chief of the Allied armies on the Western front during World War I. (Courtesy BPL.)

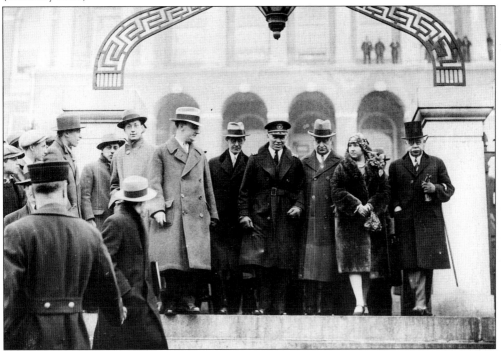

Captain George Fried and his wife pose for photographs on the steps of the State House after meeting with Governor Frank Allen in February 1929. Captain Fried was lionized after taking part in a rescue effort that saved the officers and crew of a sinking Italian freighter a few weeks earlier. (Photograph by Leslie Jones, courtesy BPL.)

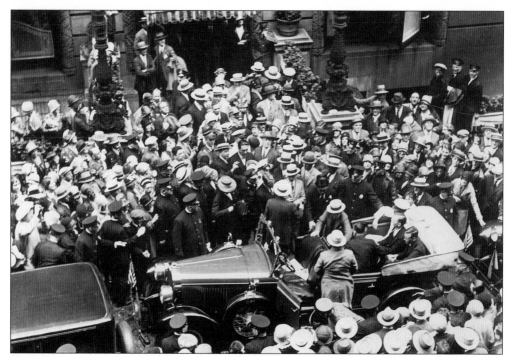

Three noted flyers—Lindy, Chamberlain, and Byrd—were in Boston at the same time. In 1927 they arrived by car at the Hotel Bellevue at 19–25 Beacon Street, built c. 1900 on the site of James Bowdoin's mansion. (Photograph by Leslie Jones, courtesy BPL.)

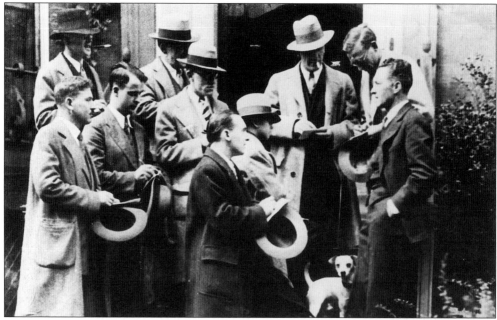

Commander Richard E. Byrd (1888–1957) was interviewed in October 1928 by newspaper reporters in front of his home at 9 Brimmer Street before leaving for the North Pole. Byrd was a twentieth-century pioneer aviator and polar explorer who won fame with his long-distance flights in the Arctic over the Atlantic. (Photograph by Leslie Jones, courtesy BPL.)

A few newsboys arrange their papers on the stoop of a vacant address on Beacon Street near Walnut Street in 1932. (Courtesy SPNEA.)

In a sign of the times, the United Boston Unemployment Relief Campaign displayed their progress on Boston Common during the Great Depression in January 1932. The goal was to collect $3 million by canvassing five thousand firms for pledges. (Photograph by Leslie Jones, courtesy BPL.)

Governor Joseph B. Ely (in office 1931–35) and Al Smith are photographed here before leaving the State House to receive their degrees at Harvard. (Photograph by Leslie Jones, courtesy BPL.)

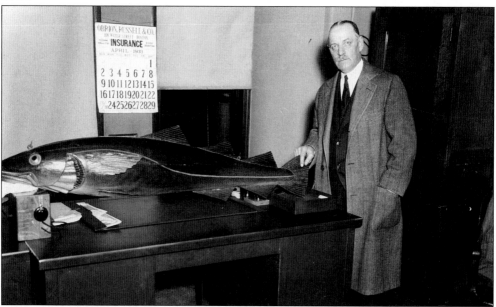

The Sacred Cod attracts media attention in April 1933. This emblem of the bygone importance of the cod to the state is a carving from pine wood and is known to have existed prior to 1784. Normally, it can be found suspended from the ceiling in the Hall of Representatives, but it made news in 1933 when the famous fish was stolen by members of the *Harvard Lampoon*. It was later returned. (Photograph by Leslie Jones, courtesy BPL.)

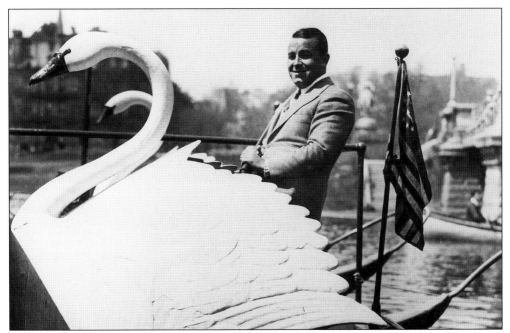

Gene Sarazen, an accomplished U.S. professional golfer, visited the Public Gardens and enjoyed the swan boats in May 1933. (Courtesy BPL.)

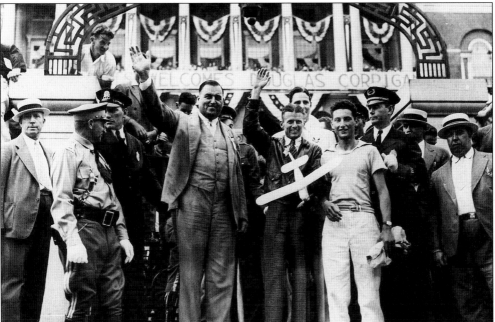

"Wrong Way" Corrigan visits the State House in 1938. Aviator Douglas Corrigan gained fame when he took off from New York in July 1938 and landed in Ireland instead of his declared destination of California. Corrigan's trip defied the orders of federal officials, who refused to approve his planned transatlantic flight. Corrigan attributed his detour to a faulty compass. His story led to a Hollywood film—in which Corrigan played himself—and a lifetime of personal appearances. (Courtesy BPL.)

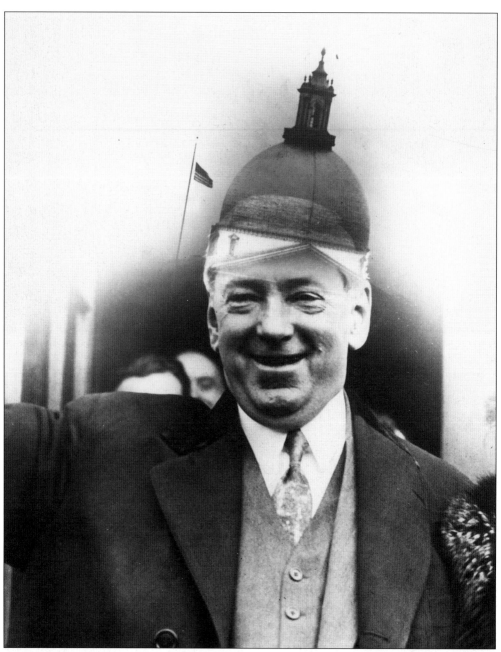

James Michael Curley wore his title like a crown after being successfully elected governor in January 1935. Curley was one of the best-known and most colorful Democratic leaders, and was favored by the working class. He became a governor (1935–1937), a congressman, and a four-time mayor. His career inspired Edwin O'Connor's popular novel *The Last Hurrah* in 1956. (Double-exposed photograph by Leslie Jones, courtesy BPL.)

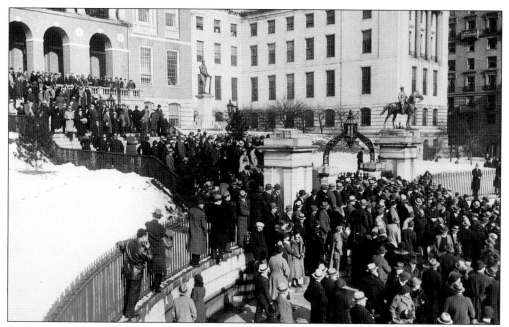

A massive crowd gathered outside the State House during Governor Curley's inauguration in 1935. Curley became notorious for his public works spending spree, which included the widening of many old Boston streets and the ambitious purchase of property for the city. (Courtesy BPL.)

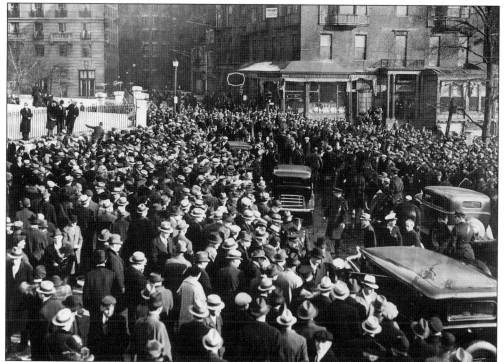

Governor Curley's inauguration in January 1935 produced a record-breaking crowd outside the State House, causing a traffic jam. (Courtesy BPL.)

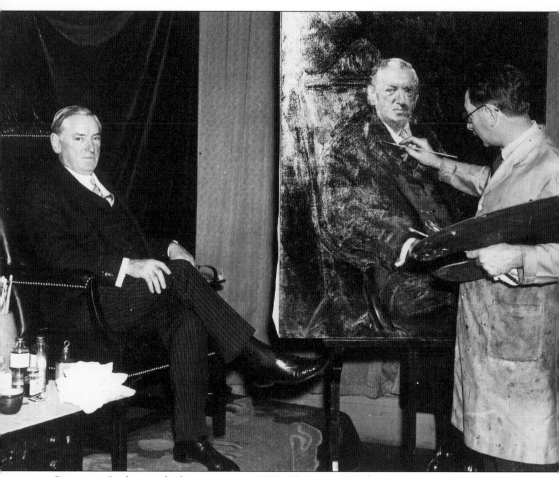

Governor Curley sits for his portrait in 1937. (Courtesy BPL.)

Six
Special Occasions

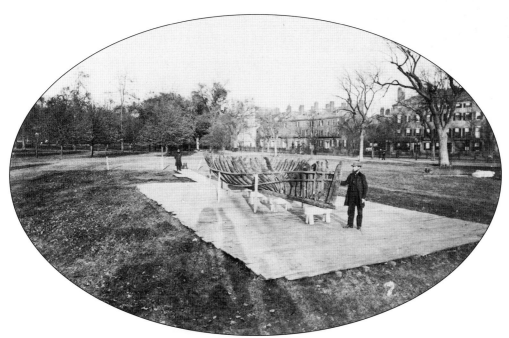

The hulk of the pilgrim ship *Sparrowhawk* was exhibited on Boston Common in 1865. (Photograph by Josiah J. Hawes, courtesy BPL.)

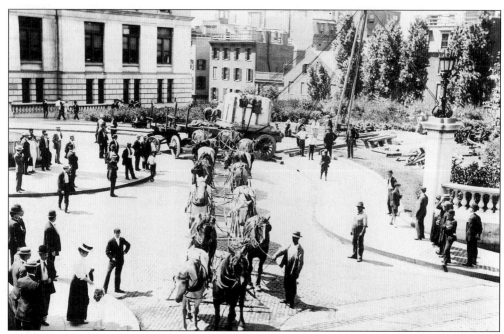

In 1889 the legislature authorized the construction of the State House extension. Shortly after, the granite works behind the State House created quite a spectacle. (Photograph by Leslie Jones, courtesy BPL.)

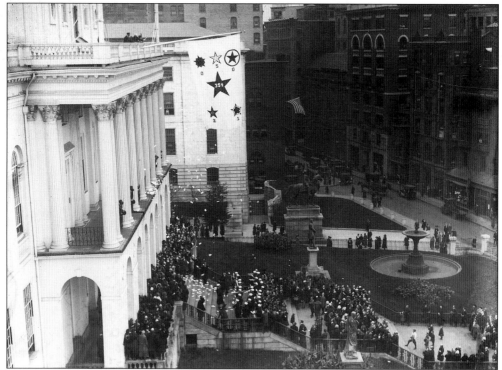

A band played on the steps of the State House c. 1918, honoring the brave men who fought in World War I. (Courtesy BPL.)

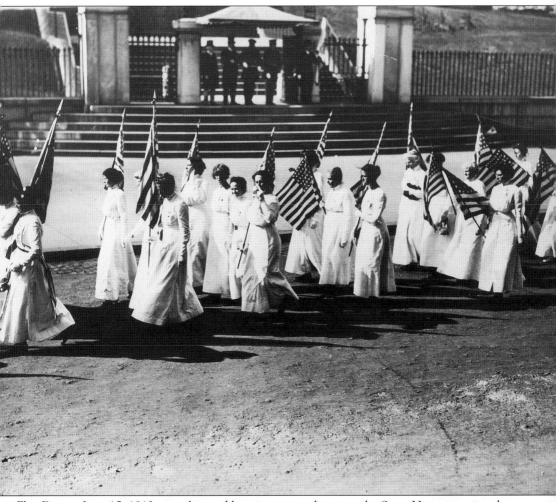

Flag Day on June 15, 1913, was observed by women parading past the State House carrying the American flag. In the early days of Beacon Hill, there were a number of parades and patriotic events each year to honor the stars and stripes. (Courtesy BPL.)

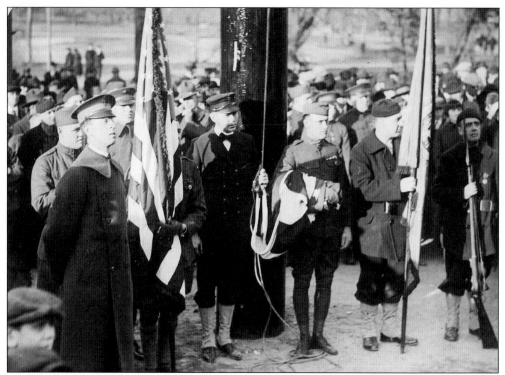

A new flagstaff being dedicated on the Public Garden, probably during World War I. From left to right are: James T. Blair Jr. (chairman of the committee), Oscar Mossman, John Ostrum, John Grant, Archie Smith, and Tom E. Ireland. (Courtesy *Boston Herald.*)

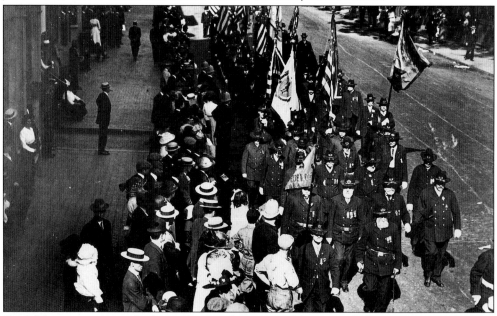

Civil War veterans parade down Beacon Street in celebration of Flag Day, June 15, 1913. During this holiday people wore the national emblem or displayed it at their homes or places of business. (Courtesy BPL.)

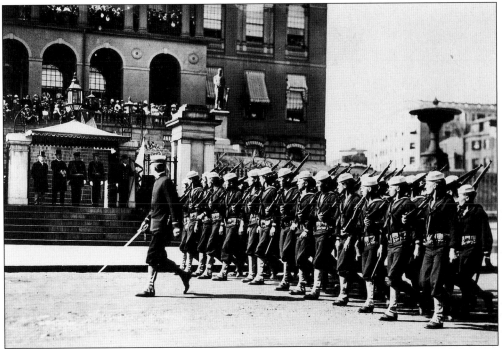

Sailors parade past the State House on Flag Day, June 15, 1913. (Photograph by Leslie Jones, courtesy BPL.)

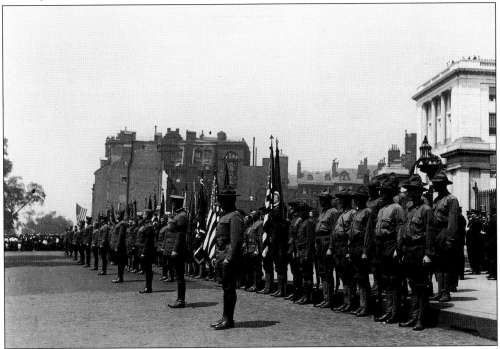

During the Flag Day Parade of June 1919, the Yankee Division ceremoniously lined up in formation to place flags from World War I in the State House's Hall of Flags. (Photograph by Leslie Jones, courtesy BPL.)

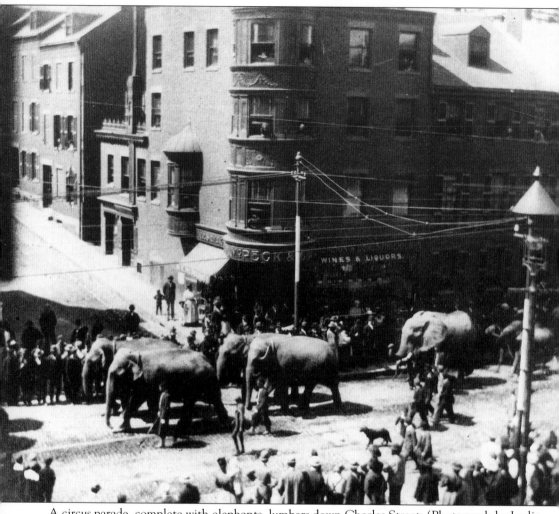

A circus parade, complete with elephants, lumbers down Charles Street. (Photograph by Leslie Jones, courtesy BPL.)

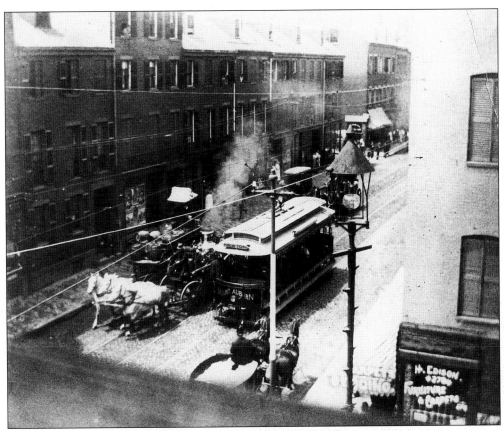

Old fire engines race down Charles Street. (Courtesy SPNEA.)

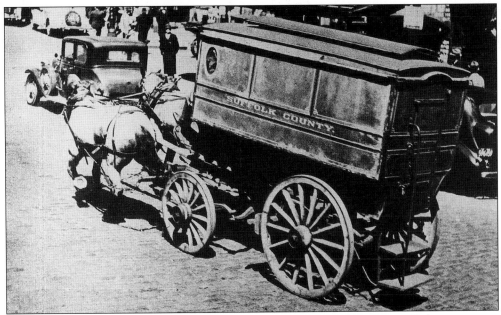

A horse-drawn jail van rushes to the Charles Street Jail, *c.* 1920. (Courtesy BPL.)

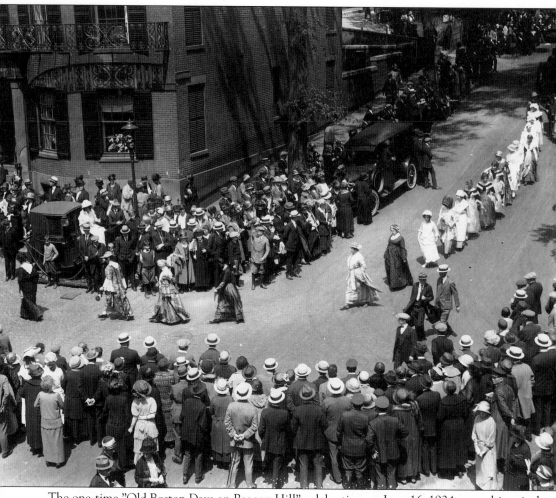

The one-time "Old Boston Days on Beacon Hill" celebration on June 16, 1924, was a historical fete that set the clock back one hundred years and benefited the Women's Municipal League. The day was dedicated to old-time pageantry, costumes, and music. Masses of people lined up to enjoy the parade at Louisburg Square. (Photograph by Leslie Jones, courtesy BPL.)

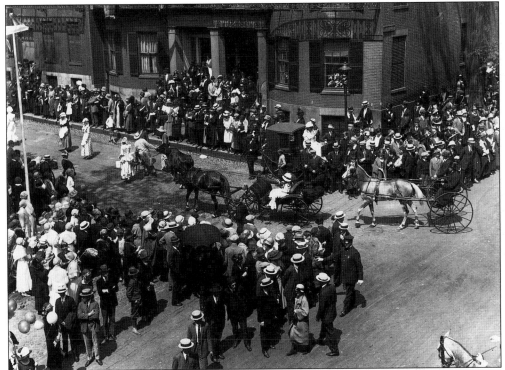

The parade filled the stoops at 1 and 3 Louisburg Square with eager spectators. (Photograph by Leslie Jones, courtesy BPL.)

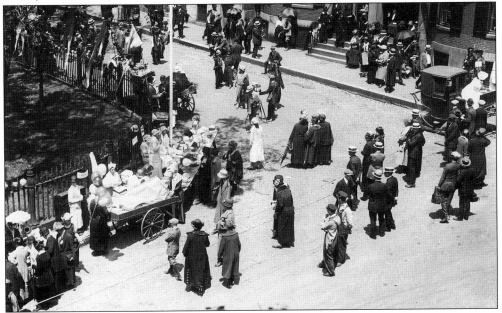

During "Old Boston Days" historic houses were open to the public, displaying antique household utensils, treasures, and customs. Meanwhile, ladies in old-fashioned kerchiefs tended their vending tables along the periphery of Louisburg Square's private park. (Photograph by Leslie Jones, courtesy BPL.)

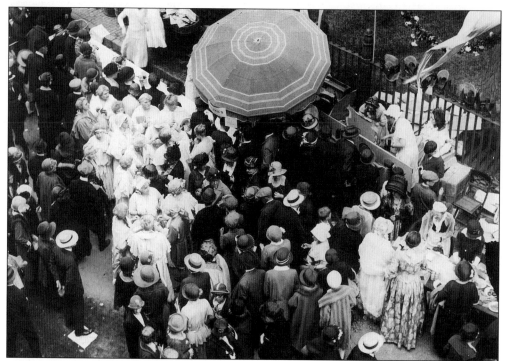

In Louisburg Square during "Old Boston Days," commerce was conducted as it had been a century earlier. Here were sold such items as antiques, books, hats, vegetables, cigarettes, and balloons. (Photograph by Leslie Jones, courtesy BPL.)

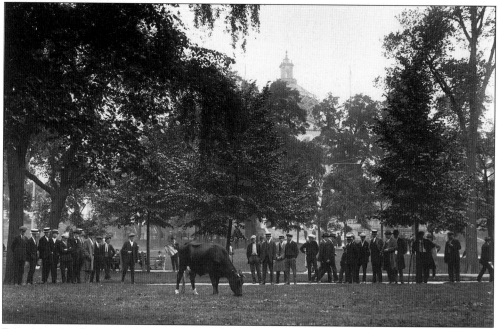

Even nineteenth-century cow-grazing was reenacted. The Lyman family, Beacon Hill residents since 1824, exercised their right to pasture the family cow on Boston Common until an old-time alarm signaled that time was up! (Photograph by Leslie Jones, courtesy BPL.)

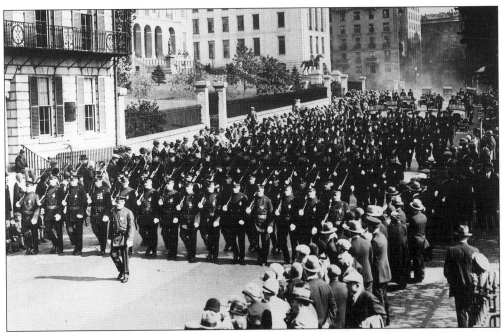

The Boston Police Riot Squad passed by the State House with their guns fixed at bayonets and flashing in the sun during one of the best annual police parades. The crack unit was loudly acclaimed by spectators who lined the streets in October 1928. (Courtesy BPL.)

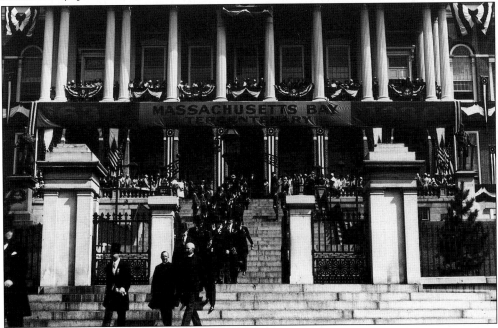

The State House was the center of activities during the 1930 tercentenary celebration. Bostonians celebrated the tercentenary of their city with a marching band, a parade, and decorations everywhere! The 300th birthday jubilee was an exuberant festival during which the city staggered various celebrations throughout the year. This procession of men decked out in tuxedos and top hats was one of them. (Photograph by Leslie Jones, courtesy BPL.)

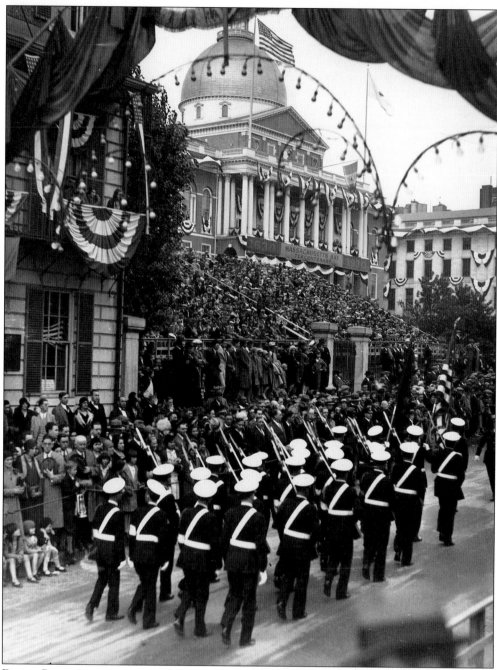

During Boston's tercentenary celebration in October 1930, members of the American Legion, paraded up Beacon Street, marching past the festively decorated State House. On holidays, Bostonians dressed up the architecture of their streets with banners and filled the major thoroughfares with marching bands. The art of draping architecture for celebration has since vanished. (Courtesy BPL.)

Sailors parade up Beacon Street during the tercentenary celebration in a procession that included forty thousand marchers, one hundred units, and two hundred floats. All parade participants passed the viewing stand with its court of honor. More than one million Bostonians massed for this moment of cheer. (Photograph by Leslie Jones, courtesy BPL.)

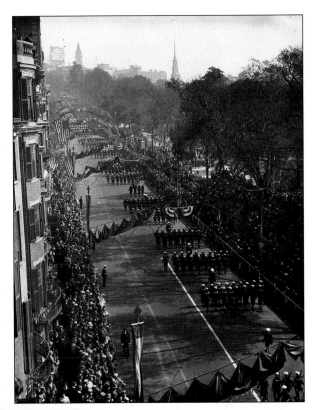

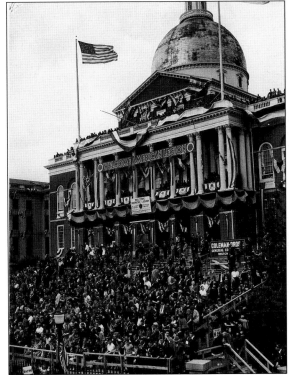

The welcoming of the American Legion delegates during the tercentenary parade filled the balconies of the State House with enthusiastic spectators on October 1, 1930. (Photograph by Leslie Jones, courtesy BPL.)

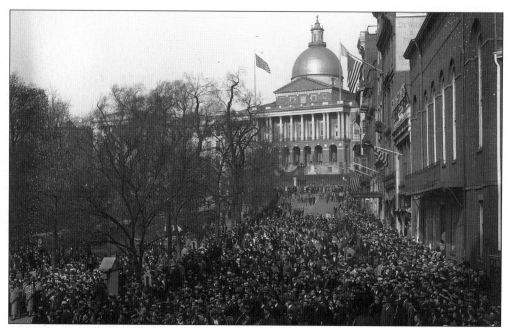

A crowd gathered to see the West Point Cadets on Park Street in November 1934. (Photograph by Leslie Jones, courtesy BPL.)

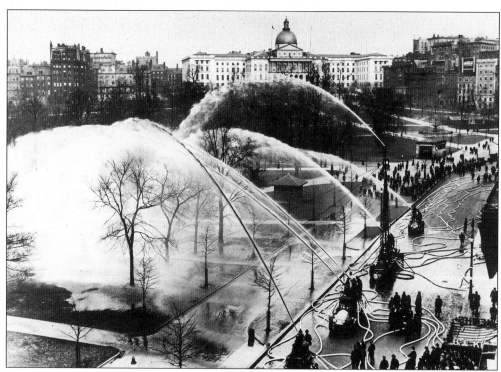

The Boston Fire Department exercised a 135-foot pressure test from Tremont Street in 1927 with the State House and Beacon Street looming above in the background. (Photograph by Leslie Jones, courtesy BPL.)

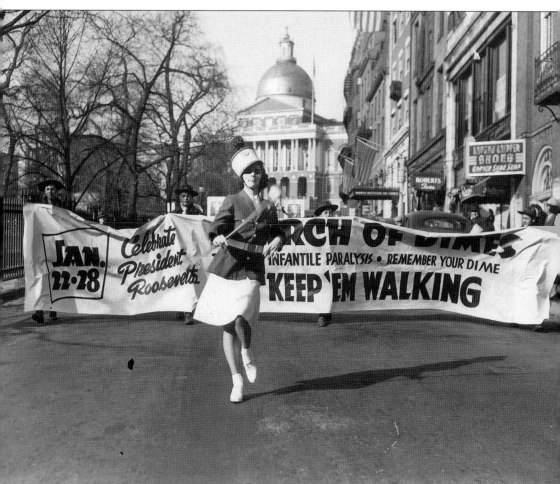

A parade down Park Street promoted President Roosevelt's March of Dimes campaign after 1934. (Photograph by Leslie Jones, courtesy BPL.)

Sons of the Veterans of Foreign Wars file past Governor Curley and his daughter at the Hall of Flags as part of an annual Washington's birthday reception on February 22, 1936. The enormous crowd was treated to a display of color and military elegance rarely seen at the State House. (Courtesy BPL.)

Governor Curley observes the parade for Washington's birthday from the reviewing stand. (Photograph by Leslie Jones, courtesy BPL.)

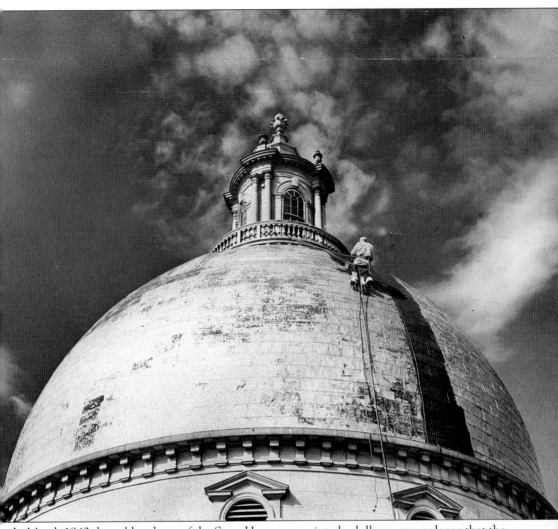

In March 1942 the golden dome of the State House was painted a dull war-gray color so that the gleaming gold would not serve as a beacon to enemy aircraft. (Courtesy *Boston Herald*.)

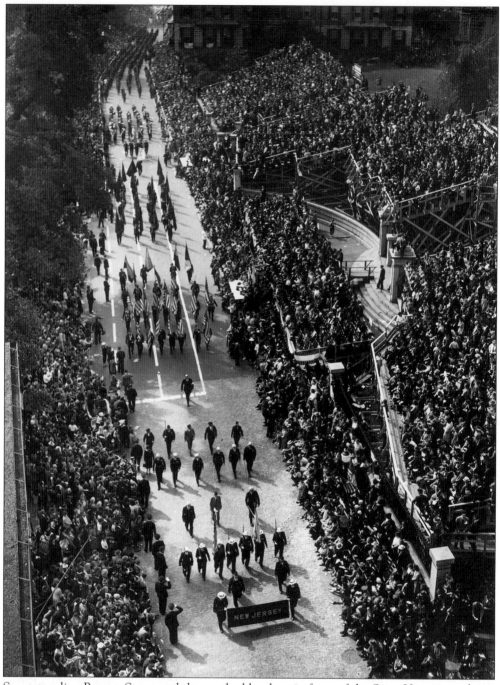

Spectators line Beacon Street and throng the bleachers in front of the State House in order to honor the American Legion. (Photograph by Leslie Jones, courtesy BPL.)

In 1947 a group of concerned women from the hill saved the brick sidewalks on West Cedar from being paved over by simply refusing to budge from the sidewalk. This became known as the "Battle of the Bricks." (Courtesy the defunct *Beacon Hill News*.)

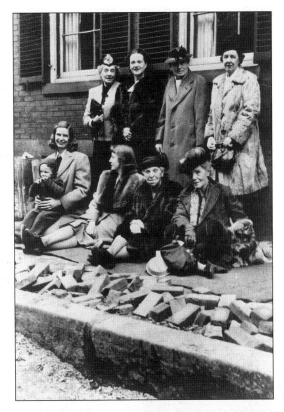

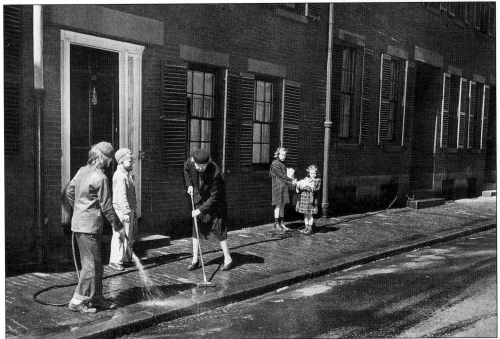

One year after the Battle of the Bricks, Mrs. F. Gordon Patterson, a participant, made sure the street and sidewalks shone for Easter in March 1948. (Courtesy *Boston Herald*.)

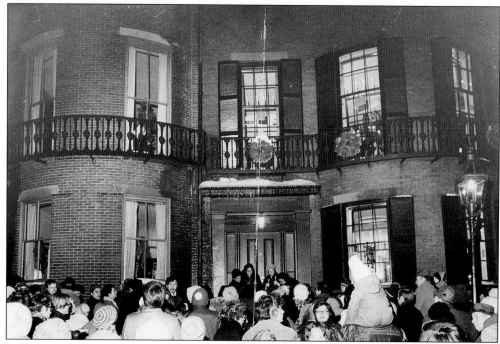

Bell ringers in 1970 revive a Louisburg Square tradition. The tradition of bell-ringing was begun by Margaret Shurcliff in 1924 when she and her six children honored the memory of Shurcliff's bell-ringing father, Arthur Nichols, by ringing bells in front of their Mount Vernon Street home. The candle-lit windows also mark a Louisburg Square holiday tradition. (Courtesy *Boston Herald.*)

Acknowledgments

Without the contributions of certain individuals and institutions, this project would not have come to fruition. My deep gratitude is expressed in particular to Lorna Condon and Anne Clifford (the Society for the Preservation of New England Antiquities [SPNEA]), John Cronin (the *Boston Herald*), Sylvia Watts McKinney and Angela Blocker (the Museum of Afro-American History), *The Beacon Hill News*, and Philip ("Pip") Barton. I am especially indebted to Sinclair Hitchings and Aaron Schmidt from the Boston Public Library, Print Department (BPL) for their generous support, direction, and expertise. Finally, none of this would have been possible without the patient and loving support of my husband, John Bartlett!